THE ANCIENT ROMANS
Their Lives and Their World

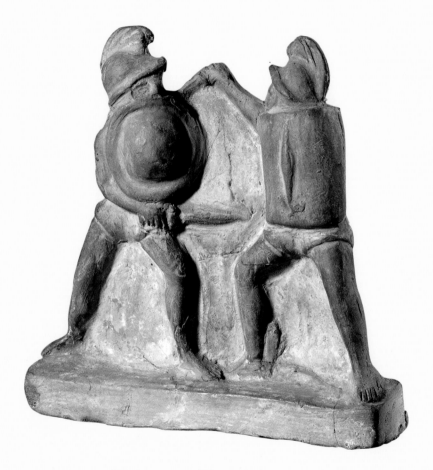

PAUL ROBERTS

The J. Paul Getty Museum, Los Angeles

Published in 2009 in the United Kingdom by
British Museum Press
A division of The British Museum Company Ltd

Designed and typeset by John Hawkins
Cover design by Jim Stanton
Printed in China by C&C Offset Printing Co. Ltd.

Published in the United States of America in 2009 by
The J. Paul Getty Museum, Los Angeles

Getty Publications
1200 Getty Center Drive, Suite 500
Los Angeles, California 90049-1682
www.getty.edu

Gregory M. Britton, *Publisher*
Mark Greenberg, *Editor in Chief*

Library of Congress Control Number: 2009923055

ISBN 978-0-89236-986-7

On the front cover: Bronze head from a statue of Hadrian, 2nd century BC, found in the River Thames in London. Wall painting of Ulysses and the Sirens, mid-1st century AD, from Pompeii. Terracotta plaque with a chariot-racing scene, 1st or early 2nd century AD, from Italy.

Illustration Acknowledgements

Unless otherwise noted below, the photographs in this book show objects from the collections of the British Museum. They were taken by the Photographic and Imaging Department of the British Museum and are © The Trustees of the British Museum.

Akg-images/Erich Lessing: 25 top right, 33 bottom right

© The Ancient Art and Architecture Collection: 55 top right, 66 top left

© The Art Archive/Gianni Dagli Orti: 59 bottom right.

© Corbis/Sygma: 72 bottom

© Foto Scala, Firenze: 55 bottom right

© Institute of Nautical Archaeology: 57 top left

© Phoenix Art Museum, Arixona, USA/The Bridgeman Art Library: 76 bottom

© RMN/Konstantinos Ignatiadis: 51 right

© Paul Roberts: 9 bottom right, 10 bottom left, 15 right, 22 bottom right, 28 left, 38 centre right, 54 bottom left, 57 bottom, 58 top right, 59 bottom left, 61 bottom left, 65 top right, 71 bottom right

© Walters Art Museum: 74-5

CONTENTS

INTRODUCTION

The city of Rome ruled over one of the greatest empires the world has ever seen. For almost five hundred years the Roman empire united all the countries round the Mediterranean Sea and much of Europe, from Spain to Syria and from Britain to Egypt.

A cameo portrait of the emperor Augustus.

Rome had a very strong army, which conquered new lands and guarded the existing empire. And what an incredible empire it was! A network of cities was linked by thousands of miles of well-built roads. The cities teemed with people from all over the world. They were filled with colonnaded piazzas, grand public buildings such as baths, temples and theatres and rich, beautifully decorated houses. An army of slaves and servants did everything from cleaning the streets to running shops and businesses and keeping the public baths heated.

A bronze model of a racing chariot.

Some parts of Rome had crowded high-rise apartment slums where the poor people lived. Noisy, smelly markets, crowded streets and the bustling city-centre Forum were filled with shops and stalls selling food, drink, consumer goods and luxuries from all over Italy and the empire. Many of the shopkeepers were women. Women were very important and very visible in everyday life, and in some ways were almost equal to men. And there were lots of children. Very many children died young because of germs and disease, so Romans tried to have big families to make sure some of them survived.

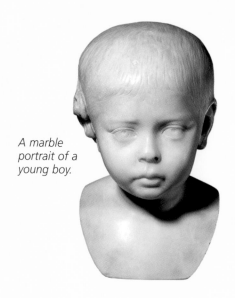

A marble portrait of a young boy.

The Roman empire ended more than 1500 years ago but it isn't forgotten. In the western world, our languages, literature, religion, architecture, laws and even the position and shape of our cities have all been influenced by Rome. Books, television and films tell us about Rome and Pompeii, gladiators and emperors. This book uses objects from the collections of the British Museum, together with pictures of Rome and other cities, to introduce you to the people of this amazing empire.

The Roman gods controlled everything. Priests and priestesses served the gods faithfully, often for most of their lives. Religious festivals were important, but they were also the time for people to relax and enjoy themselves, often by watching 'the games'. There were no organized team games, like today's cricket and football. Instead there were chariot races, beast fights and gladiator combats.

Romans also liked the theatre, where they could watch sad or funny plays. Actors, charioteers and gladiators were like today's rock stars, TV celebrities and film stars all rolled into one!

Painted portrait of a woman from Roman Egypt.

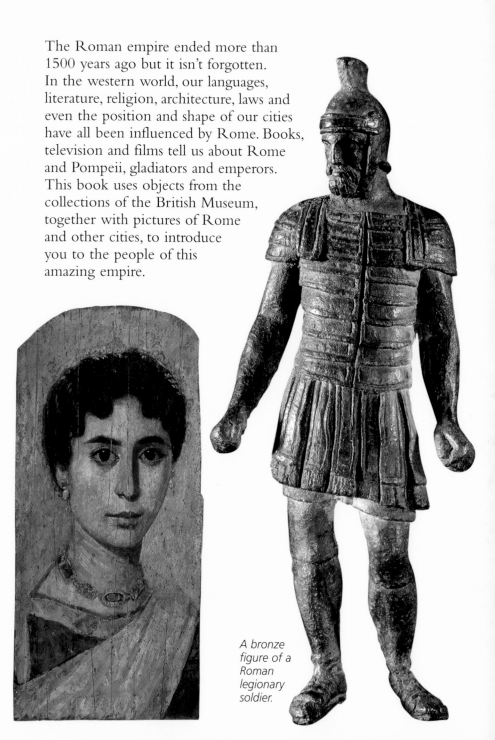

A bronze figure of a Roman legionary soldier.

MAP OF THE ROMAN EMPIRE

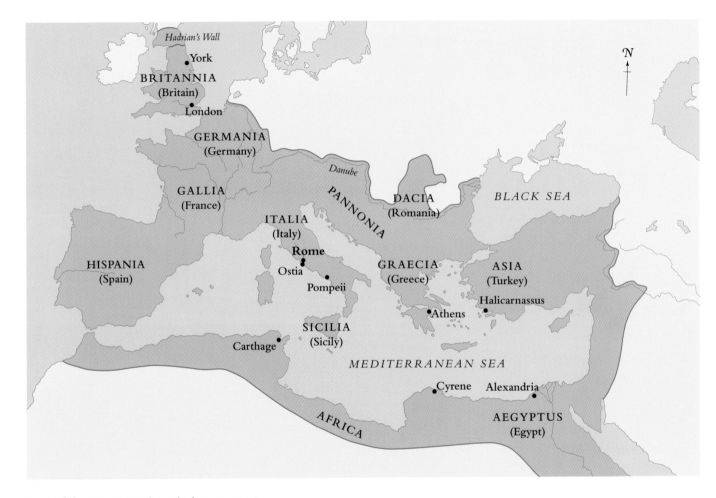

Map of the Roman empire at its largest extent,
in around AD 117.

TIMELINE

2000–1000 BC	The first farming villages are built near the river Tiber, in the area that will later become the city of Rome.
753 BC	Mythological date that Romulus founds Rome.
753–509 BC	Seven kings rule Rome.
509 BC	Tarquin the Proud, the last king of Rome, is expelled from the city. The Roman Republic begins.
264–202 BC	Rome fights three wars against Carthage, the north African city that ruled the western Mediterranean.
200 BC	Rome defeats the Carthaginian general Hannibal and conquers all of Italy.
146 BC	Rome destroys Carthage and Corinth, the capital of Greece. Rome now rules the Mediterranean.
55–54 BC	Julius Caesar leads military expeditions to Britain.
44 BC	Julius Caesar is killed by Romans who fear he is taking too much power. The Roman republic ends.
27 BC	Octavian becomes Augustus, the first emperor. The Roman empire begins.
AD 64	The Great Fire of Rome.
AD 79	The cities of Pompeii and Herculaneum are destroyed by the eruption of Mount Vesuvius.
AD 80	The Colosseum is completed.
AD 117	Hadrian becomes emperor after Trajan's death. The empire is at its largest extent.
AD 213	Caracalla declares every free person in the empire to be a citizen.
AD 313	The emperor Constantine legalizes Christianity.
AD 330	Constantine builds a new Christian capital at Constantinople (Istanbul).
AD 391	Theodosius closes all pagan temples.
AD 395	The empire officially splits between east and west.
AD 410	Rome is burnt by the barbarians.
AD 476	The western Roman empire falls. Romulus Augustulus, the last western Roman emperor, is sent into exile.
AD 1453	Constantinople is captured by the Ottoman Turks. End of the eastern Roman empire.

1 KINGS

At first, Rome was ruled by kings. Some of these kings are known only through stories. Romans thought their first king was Romulus. Romulus was abandoned with his twin brother Remus near the Palatine Hill in Rome, and a she-wolf raised them.

> A she-wolf making her way down for a drink heard crying and found the babies in their basket. A shepherd came by and found her feeding them and licking their faces.
>
> Livy

A burial vase, in the shape of an early Roman house.

Silver coin showing the she-wolf with Romulus and Remus.

When they grew up, Romulus killed Remus and ruled as Rome's first king. Archaeologists have found traces of villages from that period, so there might be some truth in the legend. The village houses were very simple – not the grand buildings we usually think of in Rome.

SEVEN KINGS

For about two hundred and fifty years, 753–509 BC, seven kings ruled Rome. They built the structure of Roman society. Romulus created the assembly of the people and the senate, a council of rich aristocrats. But Rome needed more people, so Romulus made it an asylum, a refuge for runaways – even criminals. He also kidnapped all the women from a nearby tribe, the Sabines! But later, the Romans and Sabines agreed to be friends.

The kings gradually captured more land and increased Rome's power and influence.

THE END OF THE KINGDOM

The last three kings were all Etruscans, from north of Rome. They made Rome a proper, united city. Tarquin drained marshy areas, created the first big city centre, the Forum Romanum, and built the Circus Maximus for chariot racing. Servius Tullius surrounded all seven of the city's hills with walls for the first time. The last king was another Tarquin, nicknamed 'the proud'. He built the enormous temple of Jupiter Optimus Maximus on the Capitoline Hill.

But Tarquin II was also a cruel king. The Romans became so angry at his bad behaviour that in 509 BC they finally threw him out of the city. The kingdom of Rome was over.

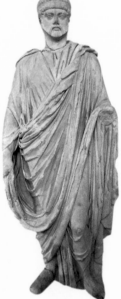

Statue of king Servius Tullius.

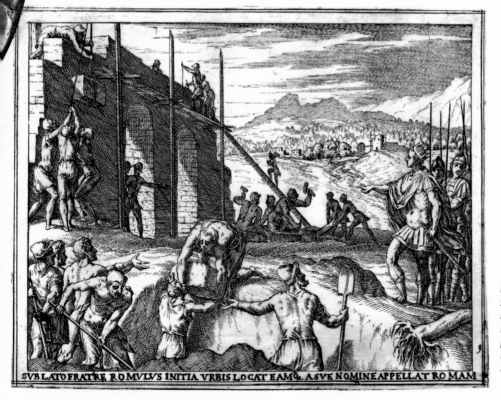

SVBLATO FRATRE ROMVLVS INITIA VRBIS LOCAT EAMQ ASVE NOMINE APPELLAT ROMAM

Romulus supervises the building of his new city. This print was made in around 1573.

2 SENATORS AND GENERALS

After the last Etruscan king was thrown out in 509 BC, Rome became a republic. It was supposed to be ruled by the people, but power really belonged to the senate, a council of six hundred rich and powerful men.

Below the senators were the consuls, who were meant to be replacements for the kings. There were always two so that one man couldn't have all the power. Then came the knights, less wealthy than the senators but still important, and finally the ordinary people, or plebeians.

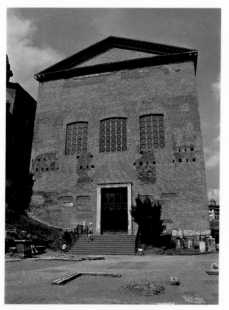

The Curia or Senate House in the Roman Forum.

Officials called lictors went everywhere with the consuls. They carried a fasces, a bundle of sticks with an axe. It meant a consul could beat you (or kill you!).

WAR AND CONQUEST

Rome had to defend herself against powerful enemies. When the last king tried to recapture Rome, one man, Horatius, single-handedly defended the wooden bridge that led into the city.

> 'You must destroy the bridge, cut it down, burn it. I'll hold the Etruscans off as best I can.' He stood there firmly on the bridge … then there was a crash of splintering wood. Fully armed, Horatius jumped into the river Tiber. Spears flew thick around him, but he swam to his own side unharmed.
>
> Livy

In 390 BC the heroes were birds! Rome was attacked and burnt by Celts from northern Europe. The last fortress, the Capitol Hill, was about to be taken when the sacred geese of the temple of Juno, queen of the gods, started to cackle and honk. This woke up the Roman guards and the city was saved.

Over the next two hundred years Rome conquered the rest of Italy. Then she started to conquer all the countries around the Mediterranean sea. Rome defeated generals such as Hannibal, who brought his army (with elephants) from north Africa into Italy.

Elephant-shaped vase, used for pouring olive oil.

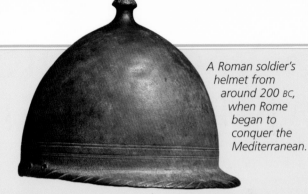

A Roman soldier's helmet from around 200 BC, when Rome began to conquer the Mediterranean.

As Rome's power grew, gold, jewels and slaves flooded into the city, especially from Greece. Rome changed for ever. People became rich. They built beautiful temples and houses, filled with statues, mosaics and paintings. But all this money caused arguments between senators, generals and the ordinary people.

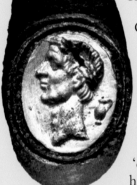

Iron ring with a gold portrait of Julius Caesar.

Civil wars broke out and the republic began to crumble. Famous generals such as Pompey and Julius Caesar tried to save it.

Caesar stopped the civil wars by declaring himself a 'dictator'. But people thought he wanted to make himself a king so he was assassinated on the Ides of March (15 March), 44 BC. The republic was over.

> The assassins closed in a circle around Caesar. Wherever Caesar turned, he met daggers. Like a wild animal in a trap, he received twenty-three stab wounds.
>
> Plutarch

3 EMPERORS

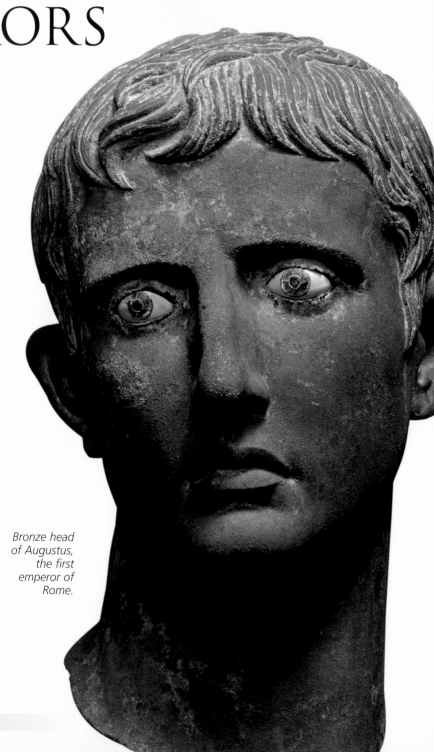

The Roman republic was officially ruled by the senate and the people, but there were others who held positions of power in Rome, including consuls, generals, and chief priests. When Augustus became the first emperor in 27 BC, he was given (or took) all the top jobs for himself. This made him, and the emperors after him, the most powerful men in the world.

Some emperors were loved by the people, for example Augustus, the founder of the empire, or the soldier emperors Vespasian and Trajan. Others, like Caligula, Nero or Domitian, were described by the Roman writers as monsters, or as very strange:

> Early in his reign he spent a lot of time catching flies and stabbing them with a sharp pen.
>
> Suetonius, describing the emperor Domitian

Bronze head of Augustus, the first emperor of Rome.

WHAT EMPERORS DID

Every emperor, good or bad, had the same powers. He was head of state (*princeps*), head of the state religion (*pontifex maximus*) and head of the armed forces (*imperator*). *Imperator* – commander in chief – gives us our word 'emperor'. The emperor's family also had important roles in Roman society. Augustus's wife Livia and later empresses were very involved in politics, and the children of the imperial family were adored by the ordinary people.

POWER AND PUBLICITY

Each emperor needed to show the empire how powerful he was, and what he looked like. He had no television, internet or newspapers, so all over the empire he set up thousands of bronze and stone statues of himself and his family. Millions of coins carried his profile and people wore the emperor's portrait on jewellery such as rings, carved stone cameos or necklaces.

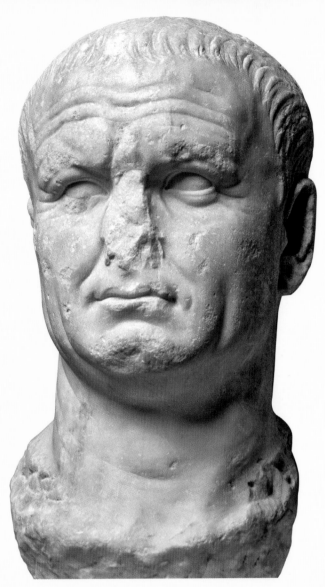

Marble head of the emperor Vespasian. He helped conquer Britain, and built the Colosseum.

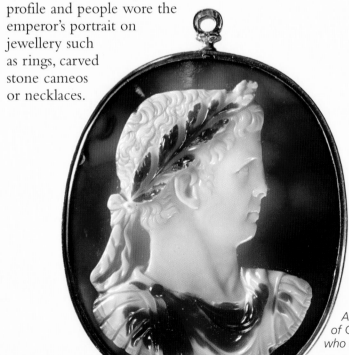

A rare gemstone portrait of Claudius, the emperor who invaded Britain.

NERO

Nero was the last of Augustus's family to be emperor. He liked to drive racing chariots and to write and perform poetry and music. At the beginning of Nero's reign the people loved him. But he changed. His behaviour became unpredictable and violent. He killed both his wives as well as his own mother, Agrippina.

Marble head of the emperor Nero.

She survived a shipwreck (organized by Nero) but was then murdered by her son's troops. When the Great Fire of Rome devastated the city in AD 64, Nero blamed the Christians, and murdered hundreds of them in horrible ways.

Nero took a large area of the burnt-out city centre and built himself a huge palace, the Golden House (Domus Aurea).

Head of Agrippina.

It was filled with beautiful mosaics, sculptures and wall-paintings.

> Every inch of the house was covered with gold and jewels. Dining rooms had ivory ceilings with openings to shower guests with flowers and perfume. The ceiling of the banqueting hall revolved just like the sky.
>
> Suetonius

and when Nero moved in he said,

'At last I can live like a human being'.

But Nero made too many enemies, and he was forced to commit suicide. He stabbed himself in the neck with a dagger, saying 'What a great artist I was!'

Fragment of painted decoration from Nero's Golden House.

HEAD OF STATE

As *princeps* (head of state) the emperor personally organized the administration of Rome and the empire. He sat in the senate house, listening to debates and passing new laws. He judged court cases, chose governors for Rome's provinces and generals for her armies. He even controlled Rome's fire brigade! People sent letters or visited the palace asking the emperor for his help and advice.

In about AD 100 the Roman writer Pliny, who was governor of one of the eastern provinces of the empire, asked the emperor Trajan how to deal with Christians. Trajan replied fairly, 'punish them if they have really done wrong, but don't hunt them down'.

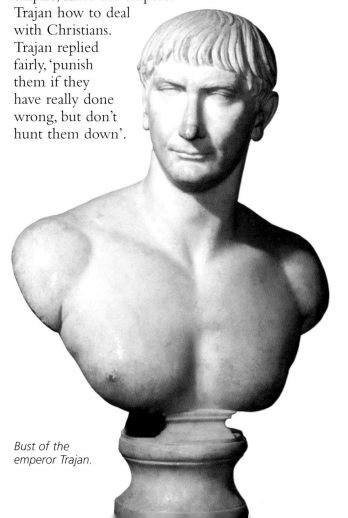

Bust of the emperor Trajan.

IMPERIAL BUILDINGS

The emperor was also the major patron of building in Rome. Augustus rebuilt so much of the city in rich imperial style – the Forum, theatres and temples – that he said:

'I found Rome a city of brick and left it a city of marble'.

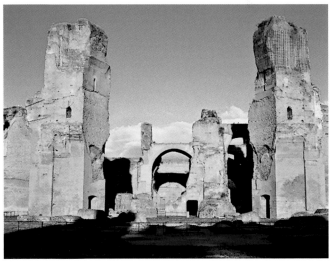

The ruins of the Baths of Caracalla.

Later emperors did the same. Vespasian and his son Titus built the enormous Colosseum for beast hunts and gladiator fights and Caracalla and Diocletian built enormous public baths (*thermae*).

Not just in Rome, but all over the empire, emperors paid for buildings, roads and bridges to show how rich, generous and powerful they were.

The emperor Trajan had this road built by cutting through mountains and eliminating the bends.
From a milestone near the River Danube, AD 100.

HADRIAN

When Hadrian became emperor in AD 117 he decided not to conquer more territory. Instead, he strengthened and fortified the empire by building defences, such as Hadrian's Wall in Britain. He wanted to see the empire's needs and problems, so he spent about ten years of his reign travelling round it. He was very well educated, and he loved Greek language and culture. He even wore a beard – a Greek fashion – and was the first emperor to do so. Some people thought he was too fond of Greek things, and nicknamed him *Graeculus* - 'that little Greek'.

Hadrian was a keen architect, and he helped design many important buildings in Rome, including the Pantheon, and his own tomb, now the Castel Sant'Angelo. He also rebuilt complete cities, such as Cyrene in Cyrenaica (modern Libya) and Athens in Greece.

At Tivoli, near Rome, he built himself a huge villa, even bigger and more beautiful than the imperial palace.

Bust of Hadrian.

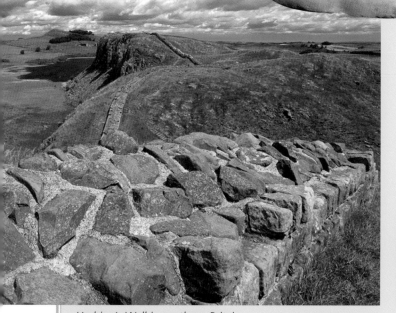

Hadrian's Wall in northern Britain.

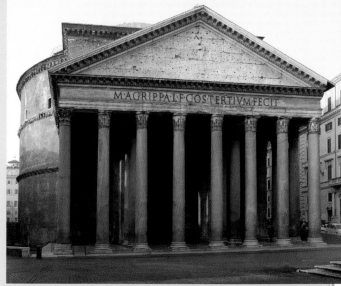

The Pantheon in Rome.

HEAD OF THE STATE RELIGION

As *pontifex maximus* (high priest) the emperor was head of the Roman state religion, with its many gods. The most important part of this religion was the sacrificing of animals. The emperor made sure that everything was done correctly and led the citizens in prayer.

Bust of Marcus Aurelius, dressed as a priest.

LIVIA – THE POWER BEHIND THE THRONE

The empress Livia was a very powerful, clever woman. She and Augustus were married for over fifty years.

Coin of Livia from a Greek city. The writing calls her 'goddess and Augusta'.

Livia wanted Tiberius, her son from her first marriage, to be emperor after Augustus, but there were several other candidates. Mysteriously, all of them died, and some people said that Livia knew all about it. She wanted her power to last for ever, and to be worshipped as divine. Augustus wouldn't allow it in Rome, but in other parts of the empire Livia got her wish. Statues showed her as part woman, part goddess.

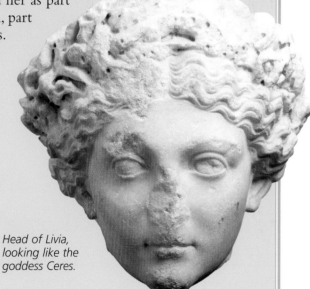

Head of Livia, looking like the goddess Ceres.

HEAD OF THE ARMY

As *imperator* (commander in chief) the emperor was the supreme head of the armed forces and soldiers and sailors swore an oath of loyalty to him. Some emperors expanded the empire. This brought in more money, territory and slaves, and it made the emperor look even more powerful. Emperors such as Augustus and Trajan sometimes led the army themselves and spent years away from Rome on campaign.

A victorious emperor returned to Rome and celebrated a 'triumph'. A triumph was a great procession starring the emperor, his face painted red to look like a god. It passed through the Forum, displaying slaves and treasure captured in the campaign. Emperors built monuments such as arches and columns to celebrate their victories. But some emperors never returned from their campaigns. Septimius Severus died in AD 211 at York in northern Britain, after fighting the tribes of Caledonia (modern Scotland).

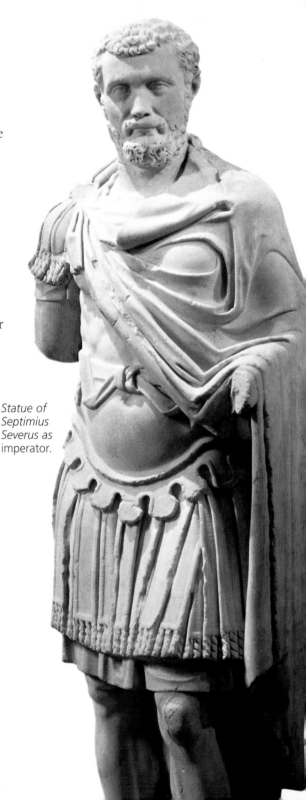

Statue of Septimius Severus as imperator.

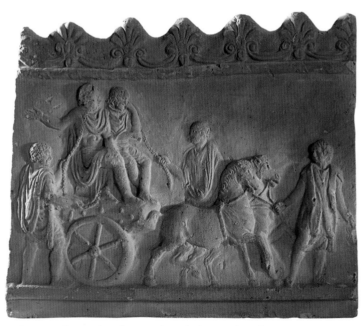

Pottery plaque showing captives during a triumph.

UNHAPPY ENDINGS?

Emperors had complete control of the empire and all its people. They had their palaces, bodyguards and enormous amounts of money. But Roman writers (as far as they can be trusted!) tell us that emperors rarely died happily.

Tiberius, Augustus's stepson and successor, was smothered with a pillow by his chief bodyguard. The next emperor, Caligula (who was probably involved in Tiberius' death), was assassinated during a theatre performance. Caligula's uncle Claudius, who followed him, was poisoned by Agrippina, his own wife.

Her son Nero, the emperor after Claudius, became so unpopular that he was forced to commit suicide. Even the great Augustus, the first emperor, was probably killed by poisoned figs – possibly served by his own wife Livia!

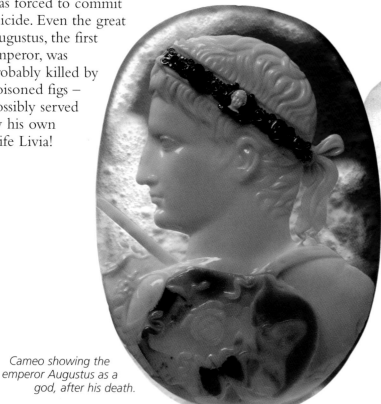

Cameo showing the emperor Augustus as a god, after his death.

Tiberius, who was murdered in his luxurious palace on the island of Capri, near Naples.

Vespasian managed to joke about dying: 'Oh heavens, I think I'm becoming a god.'

4 GODS AND GODDESSES

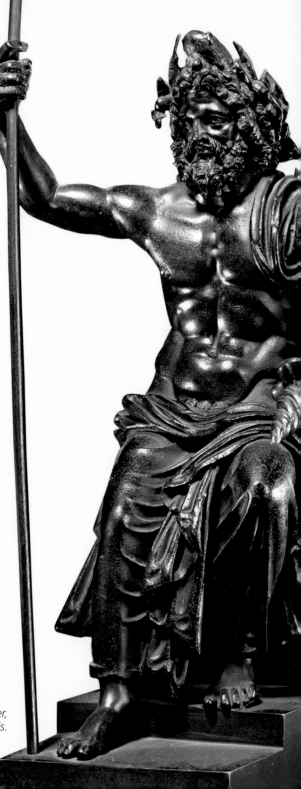

Rome had many gods and goddesses, and each one had control over a different area of daily life. The twelve gods of the state religion were the most important. They were very like the twelve Greek Olympian gods, but they had different names and sometimes different responsibilities. Three of them were especially important. Jupiter (Greek *Zeus*) was the king of the gods. His queen Juno (Greek *Hera*) was the protector of women, especially in childbirth. Their daughter Minerva (Greek *Athena*) was the goddess of arts, crafts and knowledge. These were the three main gods of Rome and they were worshipped in the Temple of Jupiter on the Capitoline Hill. Venus (Greek *Aphrodite*), goddess of love, beauty and fertility, was believed to be the ancestor of Romulus, the founder of Rome. Julius Caesar said he was descended from the goddess too.

> Julius Caesar built the temple to his ancestor Venus Generitrix … inside he put a beautiful statue of his lover Cleopatra – it's still there.
>
> Appian

Bronze statuette of Jupiter, the king of the gods.

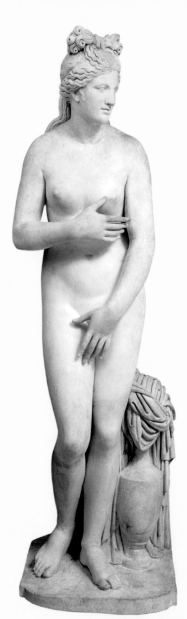

Marble statue of Venus, the goddess of love and beauty.

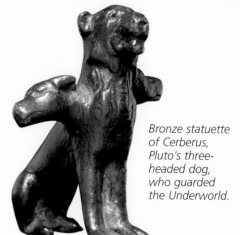

Bronze statuette of Cerberus, Pluto's three-headed dog, who guarded the Underworld.

The other major gods were Apollo (Greek *Apollo*), god of the sun, light and music, Mars (Greek *Ares*), god of war, Bacchus (Greek *Dionysos*), god of wine and fertility, Ceres (Greek *Demeter*), the goddess of corn and agriculture, Vesta (Greek *Hestia*) the goddess of the hearth and home, Neptune (Greek *Poseidon*), god of the sea, Pluto (Greek *Hades*) god of the underworld, and Vulcan (Greek *Hephaistos*), god of fire and volcanoes.

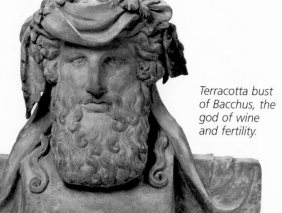

Terracotta bust of Bacchus, the god of wine and fertility.

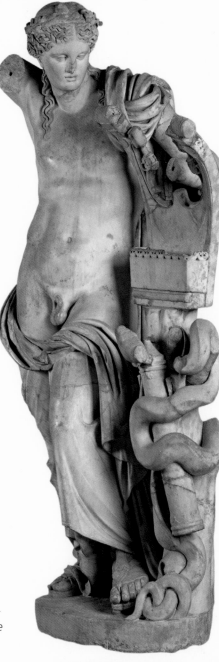

Marble statue of Apollo with a lyre (a stringed instrument) and his sacred snake.

THE MINOR GODS

Some gods were linked to the countryside, including Pomona, the goddess of fruit, Faunus (Greek *Pan*), the god of woods and wild land, and Lupercus the god of shepherds and flocks. One of the most unusual gods was Robigo, the god of mould and failed crops – farmers prayed to him to stay away!

There were also demigods or heroes, who were half-human and half-god, such as Hercules (Greek *Herakles*). Hercules was worshipped because people believed he was a bridge between humans and gods. The twelve tasks, or labours, of Hercules were very popular in Roman art and mythology.

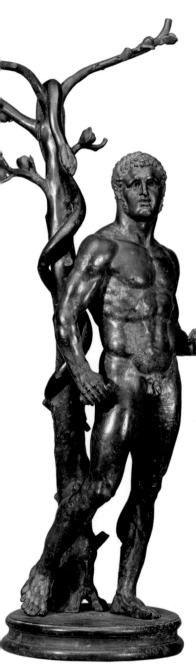

Bronze statuette of Hercules. He has just taken the golden apples – one of his twelve tasks.

Stone cameo showing two royal princesses as goddesses.

EMPEROR-WORSHIP

During the empire an important part of Roman religion was emperor-worship. People began to worship the emperors and their families as living gods.

Augustus didn't like the idea of this in the city of Rome itself, but allowed it in the other parts of the empire. Temples were set up for emperor-worship, and statues and beautiful jewellery showed the emperor and his family with the faces or the clothing of the gods. After emperors died they were made into gods (deified) by a decree of the senate.

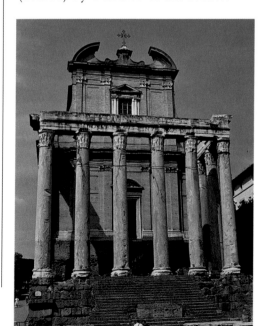

The temple of the deified emperor Antoninus Pius and his wife Faustina in the Forum in Rome.

DOMESTIC WORSHIP

Religion was not always so grand. Ordinary people had shrines to the gods in their own homes and on the street corners of their neighbourhoods. People made simple offerings of chickens, small animals, or wine. To ordinary people this domestic worship was very important. Most Roman houses had a shrine for the *Lares*, the spirits of their ancestors, called a *lararium*. The *Lares* and *Penates*, the patron gods of the family, guarded the house and everyone in it.

Bronze statuette of a lar, a household spirit.

FOREIGN GODS

The empire grew to a huge size and the many different peoples conquered by Rome had their own gods and goddesses. The Romans usually let conquered peoples go on worshipping their own gods, and even adopted foreign gods into Roman religion. For example, the strange mystical cult of the eastern goddess Cybele, the Great mother, came to Rome from the part of Asia now called Turkey.

A legend said that Asclepius, the god of medicine and healing, came to Rome from Greece because the Romans prayed to him to rescue them from a terrible plague.

Men who had served in the army, immigrants and slaves brought other important gods to Rome. The worship of the goddess Isis and her husband Serapis came from Egypt. Temples were built to her all over the empire. In Rome she had a huge temple in the centre of the city. At Pompeii her temple was beautifully decorated with paintings showing her festivals and ceremonies.

Stone relief thanking Asclepius and his daughter Hygeia for helping to heal a bad leg.

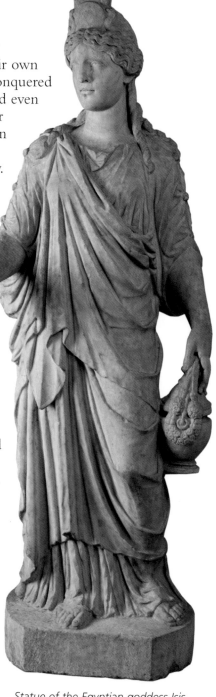

Statue of the Egyptian goddess Isis.

NEW RELIGIONS

In the third century AD the empire was in political and military trouble. Many people stopped believing in the old gods and turned to religions that promised them a better life after they died. They often converted to religions that had only one god – they were *monotheist* (from the Greek words 'one god'). Some chose Mithras, a god originally from Persia (modern Iran).

Mithraism was particularly popular with the army, because just as in the army, a follower of Mithras could be promoted through the ranks. He started off as a beginner, called a soldier (*miles*) but could reach the highest level, called father (*pater*).

People also started worshipping the sun god Sol or Phoebus and around AD 220 the emperor Heliogabalus built a huge temple to Sol in Rome.

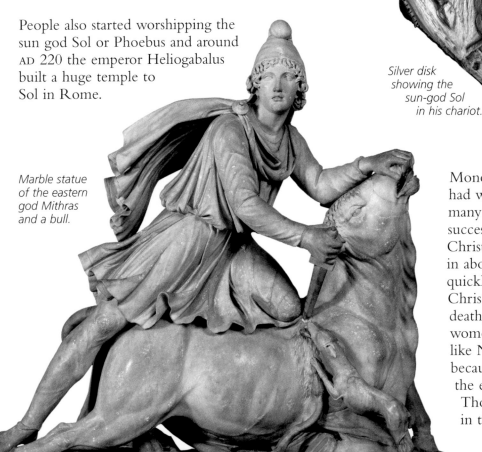

Silver disk showing the sun-god Sol in his chariot.

Marble statue of the eastern god Mithras and a bull.

Monotheism was not new. The Jews had worshipped their one god for many centuries, but the most successful monotheist religion was Christianity. After the death of Christ in about AD 35 the new religion spread quickly, especially amongst the poor. Christianity promised a better life after death, and it included everyone, even women and slaves. Some emperors, like Nero, persecuted Christians because they would not sacrifice to the emperor and the empire.

Thousands of Christians were killed in the racing circus or the arena.

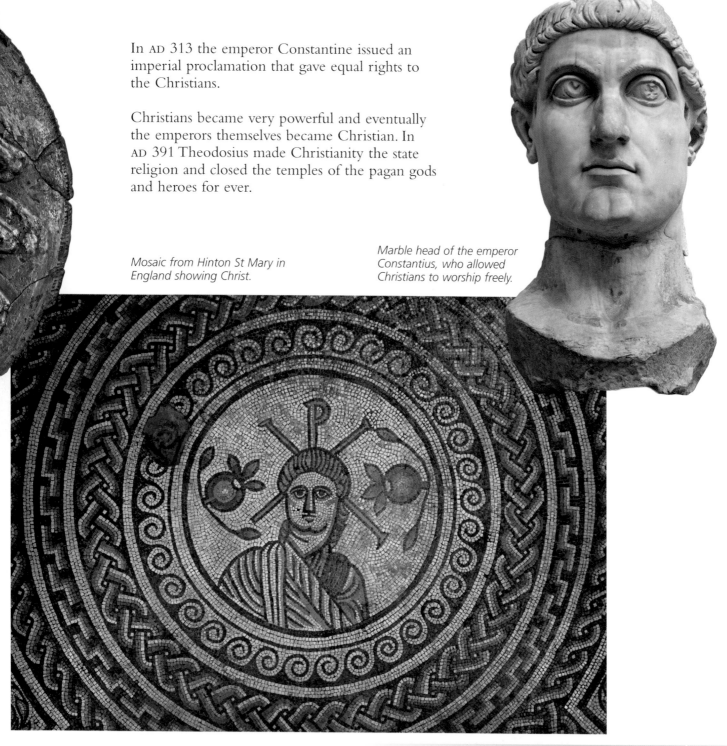

In AD 313 the emperor Constantine issued an imperial proclamation that gave equal rights to the Christians.

Christians became very powerful and eventually the emperors themselves became Christian. In AD 391 Theodosius made Christianity the state religion and closed the temples of the pagan gods and heroes for ever.

Mosaic from Hinton St Mary in England showing Christ.

Marble head of the emperor Constantius, who allowed Christians to worship freely.

5 PRIESTS AND PRIESTESSES

The many gods and goddesses of Rome had to be looked after and kept happy so that they would protect Rome and keep the empire, the emperor and the people safe. Festivals and sacrifices had to be organized, and there was an army of priests and priestesses to do this.

> Oh Jupiter the Best and Greatest, we sacrifice to you this splendid bull as it is written in the holy books so that good fortune may come to the Roman people.
>
> An inscription from Rome

Bronze head of a young priest. The band around his head shows his status as a holy man.

SACRIFICES TO THE GODS

The Romans consulted the gods before beginning any important project – declaring war, putting up a new building, making a journey, getting married or having children. If you wanted to consult the gods you had to give them presents, called offerings or sacrifices. People sometimes made libations, liquid offerings of wine, milk or honey. They also burnt fragrant incense on the gods' altars. But the most important offering was the sacrifice of living animals.

Sacrifices took place at the altar outside the temple. There were fixed rules for exactly how to carry out a sacrifice.

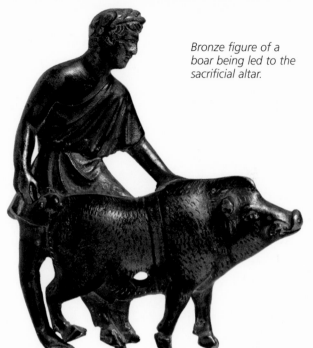

Bronze figure of a boar being led to the sacrificial altar.

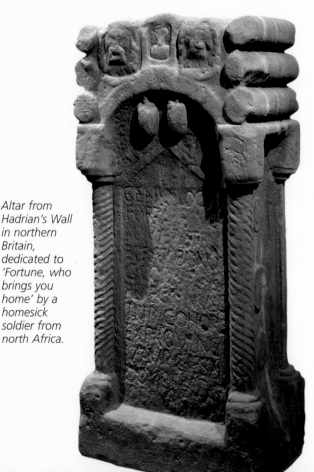

Altar from Hadrian's Wall in northern Britain, dedicated to 'Fortune, who brings you home' by a homesick soldier from north Africa.

In Rome the emperor was the head priest (*pontifex maximus*) of the state religion. He made sure everything was done correctly. Priests led the sacrificial animal, wearing beautiful ribbons or sashes, to the altar. The emperor, with part of his toga brought up to cover the top of his head, recited a prayer, using exactly the right words. Then the animal was killed, by having its skull smashed with an axe, or by having its throat cut with a special knife.

A bronze patera, or sacrificial bowl.

A bronze sacrificial knife.

VESTALS

One of the oldest and most important cults in Rome was the worship of Vesta, the goddess of the hearth and the home. Her round temple in the Forum contained the city's eternal flame.

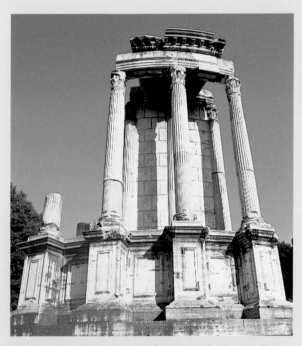

The remains of the Temple of Vesta in the Roman Forum.

The seven priestesses of Vesta, the Vestals, were chosen from girls between the ages of six and ten. They served the goddess for at least thirty years. The Vestals had great power and public respect and they were given state bodyguards. Vestals had the right to buy and sell property, and were given the best seats at public events, for example at the theatre or the Colosseum.

The duties of the vestal princesses were to keep the sacred fire burning and make sacred cakes for the festivals of Rome's gods. They also had to promise to stay pure and untouched by a man. There were terrible punishments if they failed in their duty. If the fire went out the Vestals were whipped. If one of the Vestals was found with a man, the punishment was far worse.

> Domitian ordered Cornelia, a chief Vestal, to be buried alive and her lovers to be clubbed to death.
>
> Suetonius

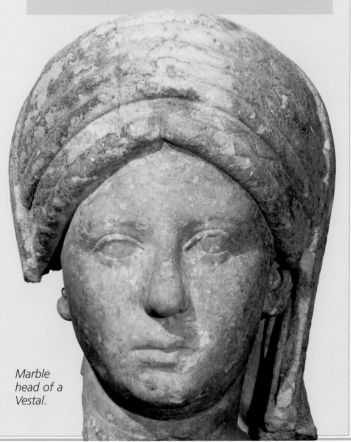

Marble head of a Vestal.

MAGIC AND TELLING THE FUTURE

The Romans were very superstitious. They believed in magic and spells, and wore amulets and charms to keep away the evil eye.

People wanted to know what would happen in the future – and they had some very strange ways of finding out. A special priest called an *augur* watched the flights of birds. Another priest called a *haruspex* examined the insides of sacrificed animals – in particular the liver, feeling all the lumps and bumps! The priests claimed that this gave them special information about what was going to happen.

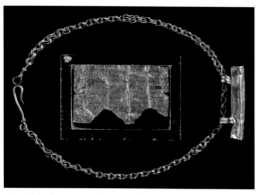

A gold charm and its carrying-case.

Romans also went to oracles, priestesses of the god Apollo, who foretold the future. In Italy there was an oracle called the *Sibyl* at Cumae, south of Rome. Tarquin, one of the early kings of Rome, bought three books of knowledge from her. Whenever Rome was in trouble people read these Sibylline books, to find out what to do.

> Augustus collected together all the prophecies and burnt over 2,000 of them. He kept only the Sibylline books and put them in two caskets under the statue of Apollo.
>
> Suetonius

WHO WERE THE PRIESTS?

High-ranking priests were amongst the most important people in society. But many ordinary people also served as priests and priestesses. Even children as young as six were chosen to train as priests of Isis and other gods.

In parts of the empire the emperor and his family were worshipped as living gods. This cult was run by priests called *Augustales*, usually ex-slaves or freedmen.

Tombstones and other sculptures sometimes show priests. Even if their title is not given we can often identify them by distinctive clothes, hairstyles, or objects they are wearing, such as headbands or wreaths.

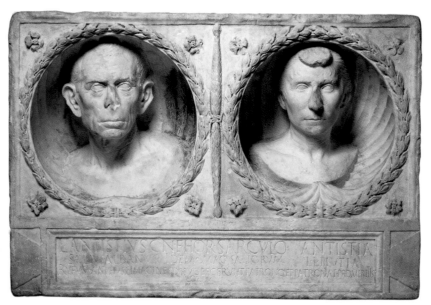

Tombstone of the priest Antistius Sarculo and his wife (an ex-slave).

6 WOMEN

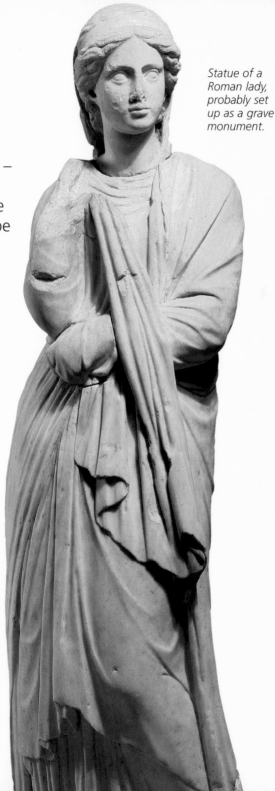

Statue of a Roman lady, probably set up as a grave monument.

The role of women was very clear in Rome's early days. A woman was supposed to be the *matrona* – the keeper of the house. Women looked after the children and the men of the household. In early Rome there were harsh laws for women – a woman could be beaten if she was caught drinking alcohol.

Roman women were responsible for raising the children. As a result, this gave them a good deal of power, because Rome needed children, especially boys who would grow up into soldiers. Rome even gave special privileges and rewards to mothers of more than three children.

Women were citizens of Rome. They couldn't vote and couldn't stand for office but they were included in Roman society. They could be seen in everyday life, go out in public, take meals with their men and even attend meetings and public gatherings. Some of these rights and privileges seem to have been taken from the Etruscans, a people who had once lived north of Rome. In other parts of the ancient world, such as Greece, women were not allowed to be part of society or even to dine with men.

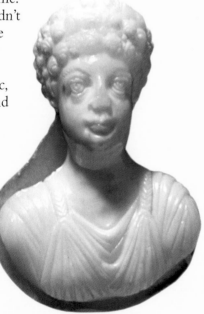

Carved gemstone showing a Roman *matrona*.

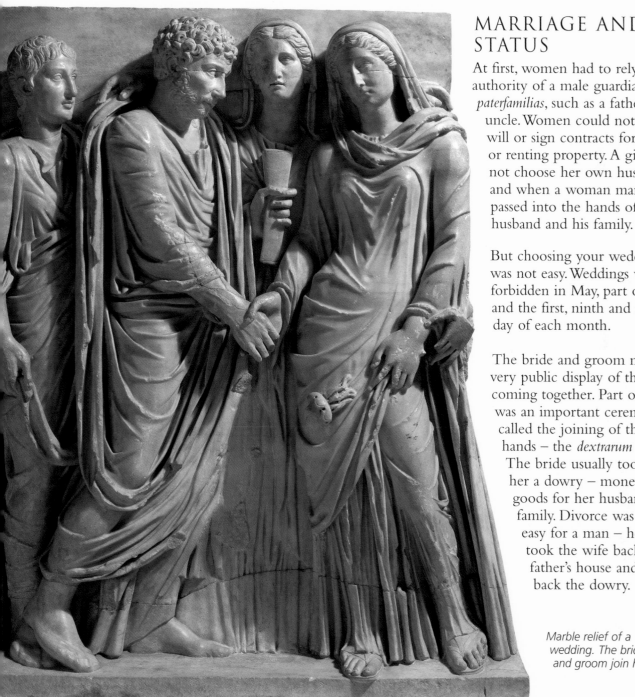

MARRIAGE AND STATUS

At first, women had to rely on the authority of a male guardian, the *paterfamilias*, such as a father or uncle. Women could not make a will or sign contracts for selling or renting property. A girl could not choose her own husband, and when a woman married she passed into the hands of her husband and his family.

But choosing your wedding day was not easy. Weddings were forbidden in May, part of June and the first, ninth and fifteenth day of each month.

The bride and groom made a very public display of their coming together. Part of this was an important ceremony called the joining of the right hands – the *dextrarum iunctio*. The bride usually took with her a dowry – money or goods for her husband's family. Divorce was quite easy for a man – he simply took the wife back to her father's house and gave back the dowry.

Marble relief of a wedding. The bride and groom join hands.

WOMEN OF THE EMPIRE

As the republic came to an end and the empire began, women's lives became much freer. Because so many men were away fighting in Rome's armies, women had more control of the household, the family and their own affairs. It became easier for a woman to marry and to divorce, to own and inherit property and to make her own will. The role of women was transformed dramatically.

Women began to use their own independent incomes and became powerful members of everyday society. Just like rich men, they spent money on public buildings for their towns and paid for festivals and games. Some men did not like this!

> There's nothing more unbearable than a wealthy woman.
>
> Juvenal

Gradually the control of a male guardian became less and less important. In the early days of Rome, women were educated only to be good wives and mothers. They learnt domestic skills and how to manage the household. Later, some women demanded a broader education.

Marble head of Livia, the wife of Augustus.

Women read literature, science and mathematics and weren't afraid to show their knowledge in public. And women suddenly saw other women gaining real power. Livia, the wife of the first emperor Augustus, was a very influential woman. Some said she was the real power behind Augustus's throne. She was the first living woman to be as visible as any man. Her statues and her image on coins were seen all over the empire – the Roman world was no longer a world of men only. Livia was soon followed by the emperor's sister, then the emperor's daughter, and soon there were images of powerful women everywhere.

A wooden writing tablet from Vindolanda Fort near Hadrian's Wall. An officer's wife invites another lady to her birthday party.

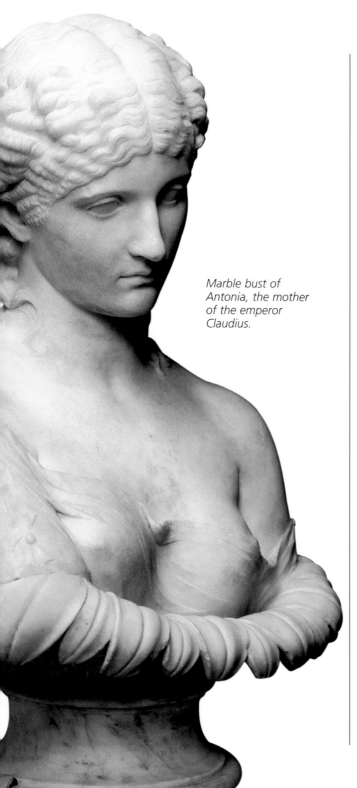

Marble bust of Antonia, the mother of the emperor Claudius.

WOMEN AT WORK

Roman writers usually only wrote about women in their own class – the nobility. But of course most Roman women were not upper class.

Part of a wall painting from Pompeii showing a man and a woman.

To find out about ordinary women, we have to look at archaeology. Gravestones are very interesting sources of information. They show women involved in the hands-on running of everything from butcher's shops to pubs and taverns. Other pictures of women, for example wall-paintings and mosaics from the cities of Pompeii and Herculaneum, show them with their husbands, sometimes running the family business. The new Roman woman had arrived.

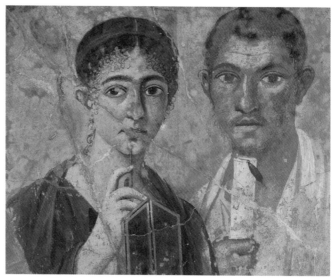

Wall painting from Pompeii showing a businessman, Paquius Proculus, and his wife.

HAIR AND BEAUTY

> Sheer beauty is power.
>
> Juvenal

Roman women of all levels in society understood that their appearance was very important. A rich woman had several servants for this, including an *ornatrix* to dress her hair and put on her make-up. Hairstyles changed, just as they do today, and people wanted the most fashionable look. At the time of the emperor Augustus, hairstyles were very simple, but a hundred years later women had big walls of curls (made using heated metal rollers) and big plaits of hair coiled into huge buns at the back of their heads.

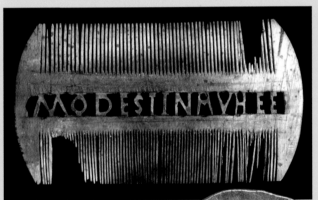

Bone comb carved with the name of its owner, Modestina.

Gold coin showing Faustina, the wife of Antoninus Pius. Women often copied the hairstyles they saw on imperial portraits.

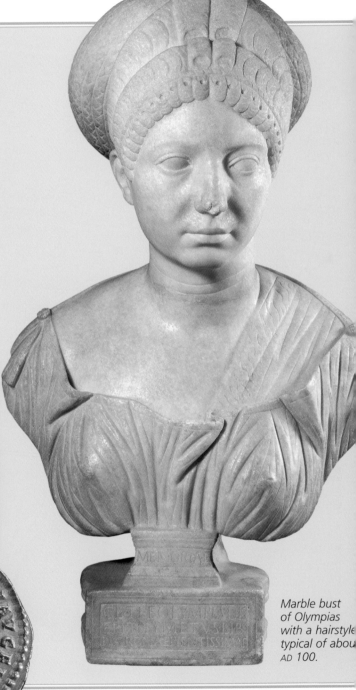

Marble bust of Olympias with a hairstyle typical of about AD 100.

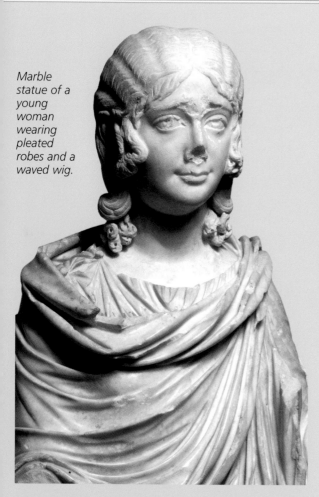

Marble statue of a young woman wearing pleated robes and a waved wig.

Make-up was very popular – but some of the ingredients were awful. Pale skin was essential for a rich woman. White face powder was made from clay or, worse, from white lead – a very poisonous substance that ate into the skin.

Lipstick and powdered rouge or 'blusher' were made from mulberries, grapes or red lead. (Red lead was just as poisonous as the white stuff.) Eye-liner was often made of pure soot. When you took your make-up off, the best face cream was made of barley, narcissus bulbs and ground-up deer antlers. Before you went to bed you could brush your teeth with a toothpaste with a special ingredient – urine ...

> When you go to sleep, your face doesn't sleep with you. It sleeps in bottles and jars on your cabinet.
>
> Martial

Many Italian women had dark hair, but some women wanted hair that was even darker, so they imported jet-black hair all the way from India, or dyed their hair. One recipe for black dye involved soaking dead leeches in wine for a month! Other women wanted blond or red hair so they spent a fortune on wigs made with hair from German or British women.

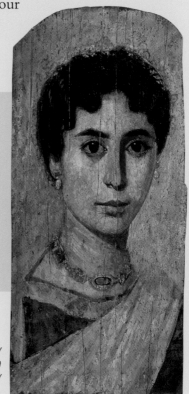

Painted mummy portrait showing a beautiful, wealthy lady from Roman Egypt.

7 SOLDIERS AND SAILORS

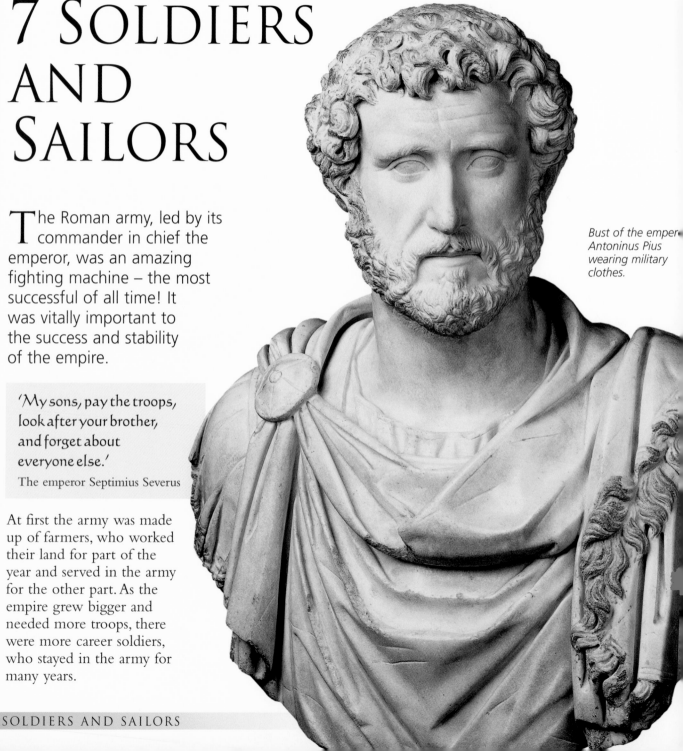

T he Roman army, led by its commander in chief the emperor, was an amazing fighting machine – the most successful of all time! It was vitally important to the success and stability of the empire.

'My sons, pay the troops, look after your brother, and forget about everyone else.'

The emperor Septimius Severus

At first the army was made up of farmers, who worked their land for part of the year and served in the army for the other part. As the empire grew bigger and needed more troops, there were more career soldiers, who stayed in the army for many years.

Bust of the emperor Antoninus Pius wearing military clothes.

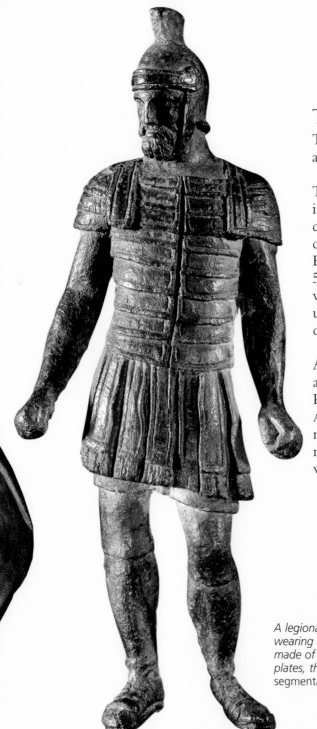

THE ARMY

The main division of the army was the legion, or *legio*.

There were about 5,000 men in a legion, divided into centuries of 80 men (like the company in today's army). Each legion also had about 5,000 auxiliaries, non-citizens who provided specialized units, such as archers or cavalry.

After twenty-five years in the army, auxiliaries were granted Roman citizenship. In about AD 200 the Roman army numbered around 300,000 men, in thirty-three legions with their auxiliaries.

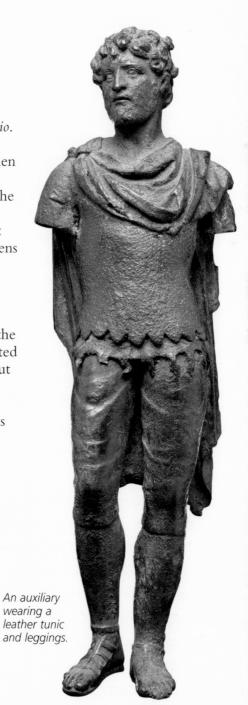

A legionary soldier wearing armour made of metal plates, the lorica segmentata.

An auxiliary wearing a leather tunic and leggings.

A ROMAN AUXILIARY

This bronze diploma was awarded to an auxiliary cavalryman called Gemellus. He had served in Britain, and when he retired after twenty-five years service, he went back to his home in Pannonia (Hungary), where the diploma was found. Gemellus's reward for his long service was Roman citizenship for himself, his wife and children.

The diploma lists the auxiliary units that were in Britain at this time. They came from all over the empire, from Spain and Africa, Germany, Hungary and Greece. Gemellus retired in AD 122, the year Hadrian visited Britain and ordered the building of Hadrian's Wall.

Roman cavalry sword, longer than the infantry gladius.

MILITARY TECHNOLOGY

Rome's success was due to the discipline and training of its troops, but also to some technological advances. Legionary soldiers wore fairly light, very protective armour made of flexible metal plates stitched together. Machines were used for besieging cities or for fighting enemies in the field. These included the *ballista*, which fired large, armour-piercing bolts with great force and speed, and the *onager* ('donkey'), which hurled rocks great distances. The *testudo* (tortoise) was a manoeuvre in which legionary soldiers linked shields over their heads and moved forward like a tank!

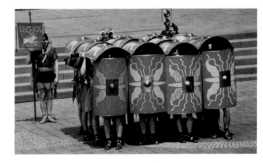

Modern re-enactors performing the testudo.

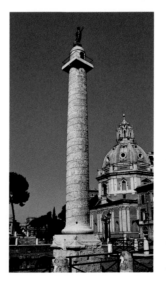

We know so much about the Roman army and its tactics thanks to the carvings on Trajan's Column in Rome.

This great monument was put up by the emperor Trajan around AD 100 to celebrate his conquest of Dacia (Romania). The carvings that spiral up to the top show the story of the campaign. There are very detailed pictures of soldiers marching, cheering the emperor, crossing rivers, besieging cities and fighting the enemy.

ARMY SETTLEMENTS

As a Roman army advanced it set up small marching camps. When an area was settled, the soldiers established permanent bases called *castra*.

A *castrum* was laid out on a standard grid, with a main east-west street, the *Decumanus*, and a north-south street, the *Cardo*. It was like a small city. As well as military activities, the army ran industries producing bricks, tiles and pottery. *Castra* often grew into big civilian settlements. The names of British cities such as Lan<u>caster</u>, <u>Chester</u> and Glou<u>cester</u> include a version of the word *castrum*, showing Roman military origins. The army built border defences such as Hadrian's Wall, and also built and maintained roads, bridges and aqueducts.

Mask worn by a Roman cavalryman at parades and special events.

Reconstructed gate at the Roman fort of Arbeia (modern South Shields) in northern Britain.

SOLDIERS ABROAD

Soldiers came from all over the empire and were often posted far from home. Wherever they went, the soldiers had a huge impact on the local area. Their Latin language began to spread amongst the local people. Roman fashions in clothing and housing began to catch on.

> I have sent you sandals from Sattua, two pairs of socks, and two pairs of underpants.
>
> A letter to a soldier serving at Vindolanda fort near Hadrian's Wall.

Wooden writing tablet from Vindolanda with a letter about socks and underpants.

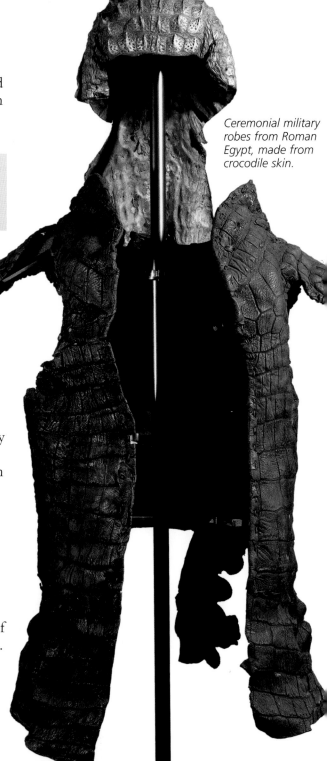

Ceremonial military robes from Roman Egypt, made from crocodile skin.

Soldiers' pay packets brought money into the local economy. Some very common English words linked to money come from the Roman army. The word 'soldier' comes from the Latin word *solidi*, the gold coins used to pay soldiers. 'Salary' comes from the word *sal* (salt), because some of a legionary's pay came in the form of a salt ration. But influences worked both ways. Some Roman soldiers began to adopt local ways, especially religion. Soldiers also started to marry local women, increasing the blending and diversity of the empire and its people.

A gold solidus *coin of the emperor Constantius.*

THE ROMAN NAVY

In Rome's early years, when she was conquering Italy, the navy was not very important. But when Rome expanded into the lands around the Mediterranean, she needed ships. The fleet really became important when Rome fought Carthage, a powerful north African city, in the third century BC. Rome finally defeated the Carthaginian navy in 260 BC, opening up the Mediterranean.

When the Romans saw that the war against the Carthaginians was dragging on, they decided for the first time to build ships, but their shipwrights were completely unused to building warships. However, one Carthaginian warship ran aground and into the hands of the Romans. They used this ship as a model to build their entire fleet.

Polybius

The sea was the easiest way to link Rome's territories, from Spain to Egypt. The navy (*classis*) fought powerful foreign states and gangs of pirates. There were several Roman fleets, stationed at different naval bases – Alexandria for the eastern Mediterranean, Misenum on the Bay of Naples for the centre. Other important fleets patrolled the Danube and Rhine rivers, and another, the *Classis Britannicus*, was based in Britain.

One of the most important battles in Roman history was fought at sea off the coast of Greece. In 31 BC Mark Antony and the Egyptian queen Cleopatra were completely defeated at the sea battle of Actium by Octavian. Octavian gained control of the Roman world. He took the title 'Augustus', and the Roman empire began.

Decorative front (prow) of a Roman ship found very near Actium.

41

8 SLAVES AND FREEDMEN

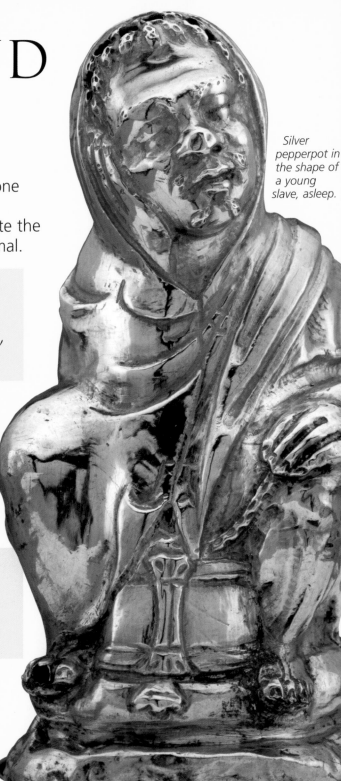

Silver pepperpot in the shape of a young slave, asleep.

Slaves are people who are owned by someone else. Millions of slaves (men, women and children) lived in Rome and Italy. Today we hate the idea of slavery, but to the Romans it was normal.

> 'People tell me you're kind to your slaves. I'm glad. They're human beings like us.'
> Some people say 'But they're slaves!'
> 'Well, I prefer to call them friends. Poor, but friends.'
> Seneca

Some people were born as slaves, others were prisoners of war, or were condemned by the Roman courts to hard labour in mines or quarries. These slaves were often kept in chains and treated very badly. Greece and other Greek-speaking countries in the Mediterranean provided many slaves, as did Gallia (modern France), Hispania (modern Spain) and Britain.

> Don't buy too many slaves from the same country. They'll only squabble.
> Pliny

Tag of a slave (or perhaps an animal) saying that the wearer should be returned to his owner if he got lost.

HARD WORK

Many slaves worked on farms. Rome and the other big cities needed huge quantities of food and drink, and most of it came from large estates. Slaves did all the work.

Wheat for Rome's bread came from Sicily and Egypt. Olive oil for food, soap and lighting the empire's lamps came from north Africa and Spain. Wine came from huge vineyards in Italy. Slaves often did hard or dirty work in the towns, too, constructing buildings and working in leather and wool factories and in laundries.

Because they were the property of their masters, slaves were sometimes badly treated.

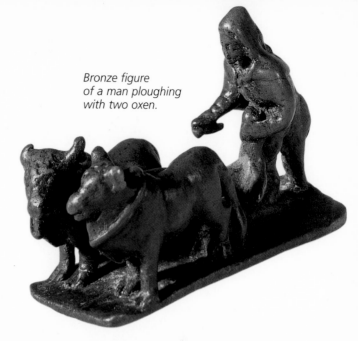

Bronze figure of a man ploughing with two oxen.

> If the mistress of the house is in a filthy mood because there is a curl out of place, then the slave girl who is doing her hair will have her own hair torn, her tunic ripped and she will be beaten with a strap.
>
> Juvenal

But life was not always bad if you were a slave. They were sometimes valued members of the household, working as teachers, cooks, librarians, gardeners or accountants. Others were artists, such as sculptors and painters. Children of slaves were sometimes brought up alongside their master's children. When special slaves died they were commemorated with beautiful gravestones and were sometimes even buried in their master's family tomb.

> Here lies Vitalis, slave of Gaius Lavius Faustus and also his son, a slave born in his home.
>
> From a gravestone found near Philippi, Greece

Terracotta figurine of a slave, heavily laden with a sack, a basket and an amphora.

FREEDMEN AND WOMEN

A slave did not always live all his or her life as a slave in the Roman empire. It was possible to become a freedman or freedwoman. A freedman (*libertus*) or a freedwoman (*liberta*) was an ex-slave, who bought his freedom, earned it through good service or was freed in his owner's will.

The ex-master protected his freedman, who had to be helpful and loyal to him. This system was known as 'patronage'. As a sign of this bond, freedmen took part of their ex-master's name as their own.

Freedmen were not full Roman citizens, and were excluded from high positions in the army and civilian society, but they dominated certain professions in which their owners could not openly take part. They were the bankers, merchants, shippers, factory owners and artisans who ran the imperial economy. Many freedmen were skilled craftsmen, making everything from sculptures, jewellery or metalwork to pottery and glass.

Drinking cup made of fluorspar, a rare stone from Persia (Iran). Many of the finest works of art were made by slaves or freedmen.

Some freedmen made large fortunes, in particular those who ran their masters' businesses. Like other wealthy Romans, they built or restored public buildings, sponsored games, owned expensive villas and gave extravagant banquets. Even after their death they wanted to be remembered as good members of society, so they built expensive tombs, with sculpted reliefs or portraits, showing them and their families posing in their best clothing as proud Romans.

Gravestone of an ex-slave called Lucius Ampudius Philomusus, a corn importer, and his wife and daughter.

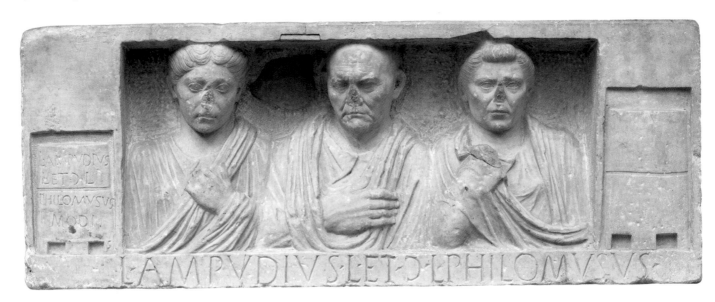

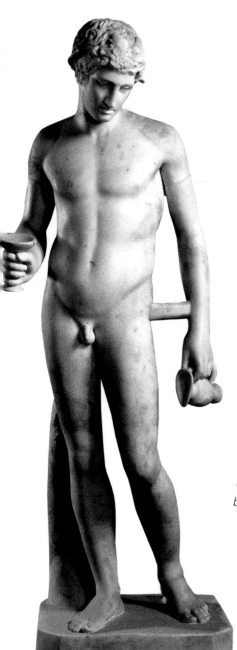

Marble statue of a young man, signed by the sculptor who made it: Marcus Cossutius Cerdo.

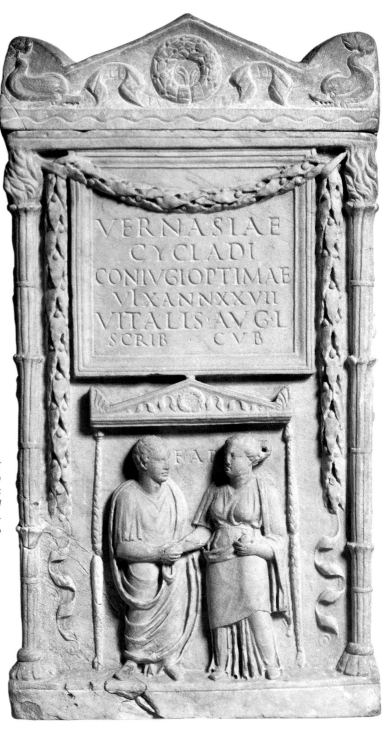

A burial chest dedicated to Vernasia Cyclas by her husband Vitalis, an ex-slave of the emperor.

VERNASIAE
CYCLADI
CONIVGIOPTIMAE
VIXANNXXVII
VITALIS AVG L
SCRIB · CVB

9 Children

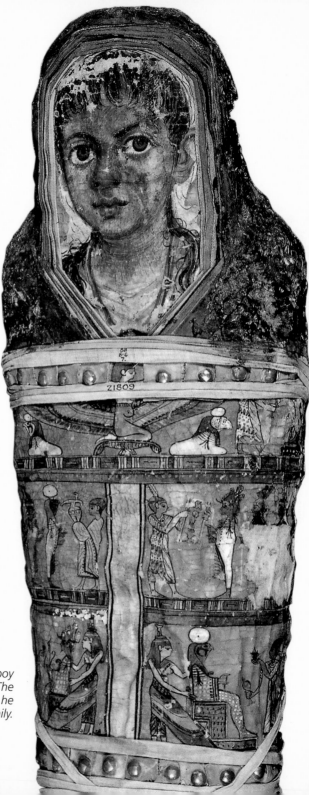

Children were extremely important to the Romans – they were the future of the city. Boys grew up and joined the army, and girls grew up and gave birth to more boys.

A child's early years could be difficult. When a baby was born its mother gave it to the man of the house, the *paterfamilias*, so he could accept it into the family. At the beginning of Rome's history he sometimes refused. If the baby was a girl and he wanted a boy, the *paterfamilias* could leave the child out in the countryside to die, or sell it into slavery.

By the time of the empire this didn't happen any more. But there were other dangers. Many children died of infections and other disease, because the Romans didn't have the skills or the medicines to save them. Not even the imperial family was safe. In the second century AD the emperor Marcus Aurelius and his wife Faustina had twelve children, but less than half of them lived to grow up. It was important to have as many children as possible, so that at least some of them would survive.

Mummy of a little boy from Roman Egypt. The decoration shows that he was from a rich family.

Gravestones of children often show them as adults, making up for the grown-up life they never had.

Emperors passed laws rewarding women who had more than three children and punishing people who had none or who didn't get married. The emperor Trajan set up a special welfare system to feed poor and orphaned children in Italy. The citizens of the future had to be protected.

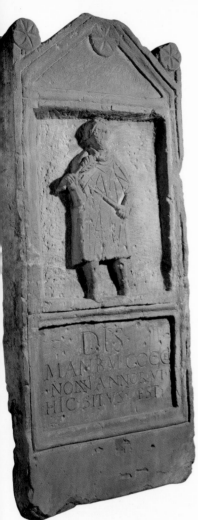

A gravestone from Hadrian's Wall of a little boy who died aged six. He is shown as a grown-up charioteer.

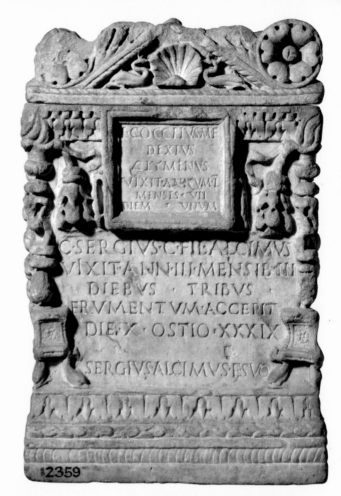

A burial chest for two little boys from Rome. It says that one of them received free corn from the government.

THE NAMING CEREMONY

When they were eight or nine days old, children were officially named at a ceremony called the *nominalia*. They were given a disc-shaped locket, or *bulla*, which contained an amulet or lucky charm. They wore these charms until they became adults.

A statuette of a young child in a walking frame, wearing a bulla.

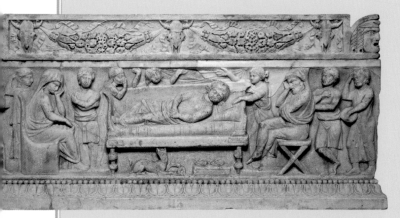

A FUNERAL

This stone burial chest, or sarcophagus, was made for a little girl who died in about AD 200. She is shown resting on soft pillows on a couch, as if she was just sleeping. At the ends of the bed are her mother and father. All around are people mourning her. They may be members of the family, or professional mourners that Romans used to hire to weep and wail at funerals. Under her bed are her slippers and her faithful pet dog.

SCHOOL AND WORK

In the richer families both boys and girls went to elementary schools. Here they learned the basics of reading and writing in Latin and sometimes Greek, and mathematics.

A girl's formal education usually finished when she was about eleven or twelve. Then she started to learn from her mother how to run the home and look after a family. Boys remained at school, learning skills such as speech-making. They also learned to ride a horse, had military training to prepare them for the army, and were often sent travelling abroad. All of this helped to make them ready for life as a Roman citizen.

Some children started public work very young. Some very young children were chosen to be priests and priestesses. For example, children under ten could be priestesses of Vesta or Isis. But if they lived, most children enjoyed a normal childhood.

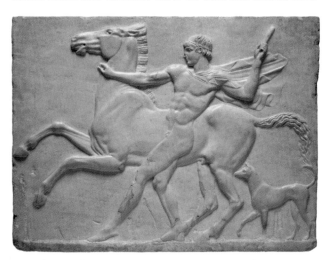

A marble relief showing a young man training a horse.

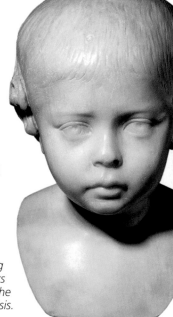

Marble bust of a young boy. His hairstyle suggests that he was a follower of the Egyptian goddess Isis.

TOYS AND GAMES

Playing was a very important part of childhood in Rome, just as it is now. There were lots of different toys. Very young children had rattles, called *crepundia*, and little charms, or bells and whistles in the form of birds and animals.

Older children had dolls made of terracotta, rags and wood. Some dolls had moveable arms and legs and sometimes they had miniature furniture such as beds and chairs. There were also little figures of gladiators, actors, slaves and soldiers – people that children saw in everyday life. There were all sorts of animal figures made of terracotta, wood and even lead (which was very poisonous – so let's hope small children didn't put them in their mouths!). Some of these animals were on wheels so they could be dragged or raced along. Children used the animals to play at peaceful farming or to recreate the terrible fights and battles of the arena.

Other toys included spinning tops, dice, knucklebones and even yo-yos. Children and adults also played board games, with special counters or with pebbles, nuts and marbles.

Children played games of chase, blind man's buff or piggy-back and also games with balls made of stuffed leather or bundles of cloth. There were some team games but nothing as organized as modern football, rugby, basketball or cricket.

Rag dolls were popular with children all over the empire. This one survived because it was buried in the hot, dry sands of Egypt.

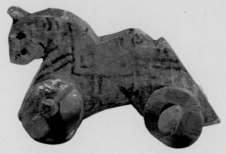

A wooden model of a horse that could be pulled along on its wheels.

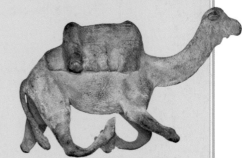

A lead model of a camel.

GROWING UP

There was no set age for officially becoming an adult, but generally by fourteen or fifteen years old boys and girls were full members of society. We don't know very much about the ceremonies that celebrated a girl becoming a woman. Most histories at this time were written by men for men, and sadly they weren't interested in girls.

His father was his reading teacher, his law teacher ... and taught his son to hurl the javelin, fight in armour and ride a horse.

Plutarch

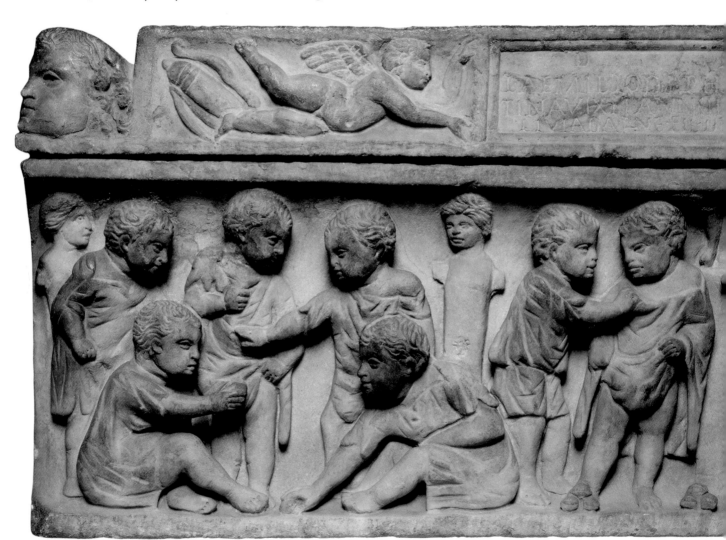

Sarcophagus of a child showing young boys playing games.

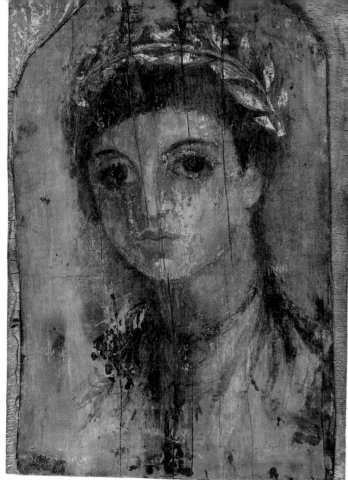
Painted portrait of a young girl from Egypt.

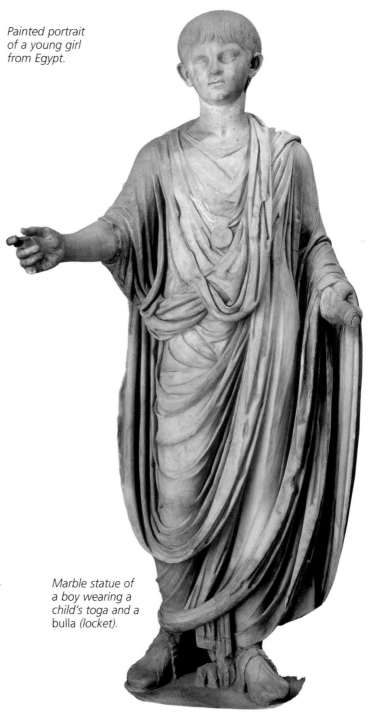
Marble statue of a boy wearing a child's toga and a bulla (locket).

When a boy became a man, it meant that Rome was gaining a new full citizen and a new soldier, so the ceremony could be very grand. The boy took off his locket (*bulla*) and dedicated it to the household gods. Then he swapped his childhood toga, with its coloured border, for the pure white toga of a man.

Afterwards the father led his son to the Forum, together with all the men of the family and all his most powerful and influential friends. Here, the boy's name was added to the list of citizens. This was the most important part of the day. The family gave thanks to the gods and then there was a huge banquet at the family home. The boy was now a man.

10 FARMERS AND FOODMAKERS

Farmers were very important in the Roman world. Much of the population lived and worked on the land. Farming was not always a full-time job, however. Farmers also served as soldiers, fighting for part of the year and farming for the rest of the year.

Rome began as a small town, and family farms in and around Rome provided all the food and drink that the people needed. These farms had plots of vegetables, fruit orchards and fields of wheat and barley to produce flour for bread. Little vineyards made wine, and local farmers and shepherds raised sheep, cattle, goats and pigs in the surrounding countryside.

Oil lamp with a picture of a shepherd and his flock under a tree.

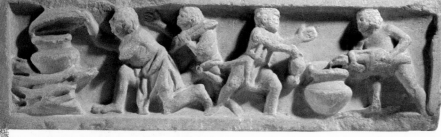

Stone relief showing people boiling wine to make defrutum, *a thicker and sweeter drink.*

Some people went out into the forests and hunted animals such as deer and wild boar.

But by about 100 BC Rome had conquered all of Italy, and her population had grown to over half a million people. The small farms couldn't produce enough food and drink, so farming changed.

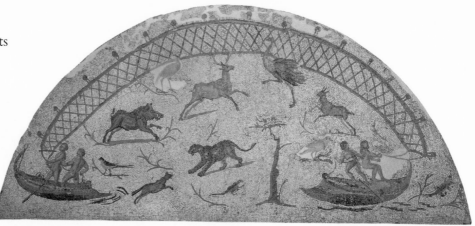

A mosaic from North Africa showing an animal hunt.

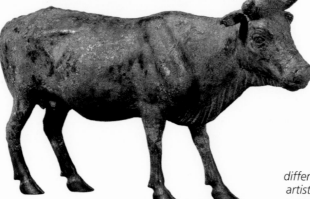

Bronze statuette of a bull. The Romans preferred to use cattle for work (pulling carts) and so they did not eat very much beef.

A mosaic from Italy showing different types of sea creatures. The artist used very small mosaic cubes, so the picture looks very detailed.

In many parts of the empire, such as north Africa, Italy and Spain, rich landowners bought up the little farms and put them together to make enormous estates called *latifundia*.

These estates produced massive quantities of wheat, olive oil and wine, and were so big that the only way to run them was with slave labour. There were plenty of slaves around from Rome's victories in countries such as Greece and Spain. Some estates specialized in rearing large numbers of pigs or sheep – the first factory farms!

Near the coast, huge fish farms produced tons of fresh or salted fish and fish sauce (*garum*).

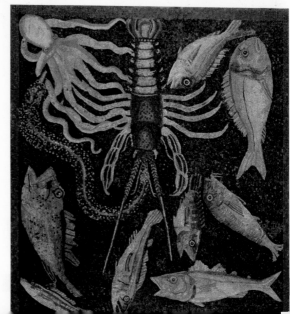

53

GARUM

Garum was a fish sauce, usually made from tuna or mackerel. To make *garum* you took the heads, tails, intestines, and bones of the fish and left them in big stone tanks with plenty of salt to ferment under the hot sun. The factories smelt awful, but the Romans loved *garum* and used it in starters, main courses and even puddings!

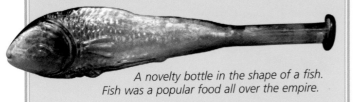

A novelty bottle in the shape of a fish. Fish was a popular food all over the empire.

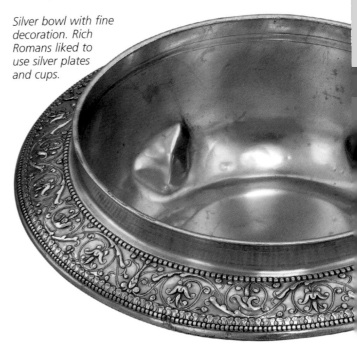

Silver bowl with fine decoration. Rich Romans liked to use silver plates and cups.

Often poor people couldn't afford the most basic foods, so Roman emperors organized cheap – or sometimes free – handouts of bread, oil and sometimes pork. On special occasions, like the emperor's birthday, they even gave out wine. People could also go to a street corner bar or tavern to buy cheap meals such as soups, pies and sausages.

Rich people's food was different. They had their own kitchens and cooks, often Greek slaves or servants.

Wealthy families competed to see who could serve the most extravagant meals or had the biggest set of silver tableware. The senate passed laws limiting the number of silver plates and banning exotic foods. One of these foods was the dormouse, a plump little mouse that Romans fattened up in special pottery jars.

The inside of a thermopolium, *or tavern, in Ostia.*

Bronze statuette of a mouse eating a nut.

ROMAN FEASTS

But Roman meals became bigger and more spectacular. Some emperors served meals with over twenty-five courses. We know what rich Romans ate because we can read a recipe book written by Apicius who lived in Rome at the time of Nero in the 50s – 60s AD.

For starters there were vegetables, eggs, cheese, snails, seafood, fish, chicken, duck and, of course, dormouse! For the main course Romans ate meat, especially goat, pork and wild boar. Apicius also gives recipes for exotic dishes like flamingo and parrot. To finish, the Romans loved puddings – including one called *libum* that was just like cheesecake. But most important was fruit, especially apples, peaches, grapes, cherries, figs and dates.

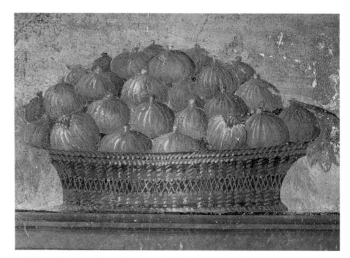

Wall painting of a wicker basket of big, juicy figs. Even the seeds are shown.

The Romans were messy eaters and by the end of the meal, the floor was covered in the bits and pieces they had dropped, from lettuce leaves to fruit pips.

RECIPES

The Romans loved exotic recipes. Dormouse should be

> stuffed with pork mince, dormouse meat, pepper, pine nuts and *garum*, rolled in honey and poppy-seeds and fried.

The best *garum* was

> … made from the blood of a mackerel that is still gasping

and the best way to serve a parrot is in a sauce made from

> vinegar, honey, onion, sesame seed and dates.

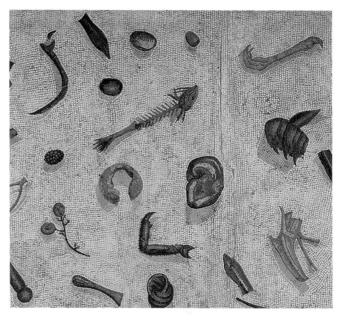

Mosaic from a dining room, showing the floor covered in food after a meal – everything from crab claws to fruit pips.

11 MERCHANTS AND TRADERS

The Roman empire was vast, with many cities and towns. These cities became richer and bigger as the empire expanded, but this created a problem. How could the emperor make sure the cities were supplied with all the goods they needed? Through an army of merchants, traders and shopkeepers!

Many merchants and tradesmen were freedmen (ex-slaves). They set up tombstones and other monuments, proudly showing the trades and skills that had allowed them to become wealthy and enter Roman society.

The Mediterranean was at the centre of Rome's empire and it became a superhighway, criss-crossed by thousands of ships carrying all sorts of cargoes.

Stone relief showing an ox cart entering a city. It is carrying a huge animal skin filled with wine.

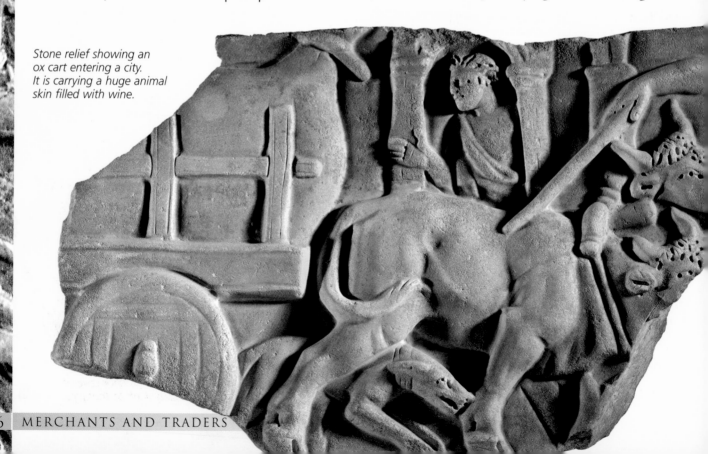

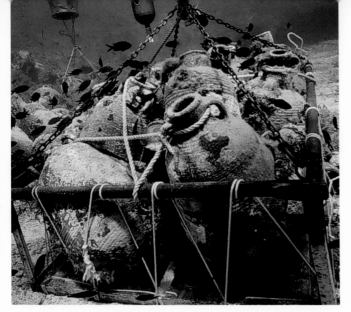

Amphorae (oil or wine jars) discovered on a Roman shipwreck in the Mediterranean.

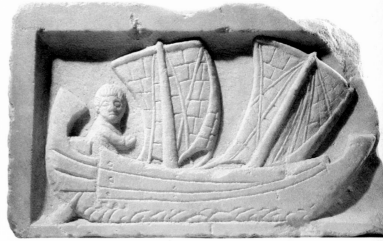

Stone relief showing a man steering a small merchant ship.

Food was the biggest and most important cargo. For bread, merchants loaded ships with enormous quantities of corn from Egypt, Sicily and north Africa. Wine came from Italy and the eastern Mediterranean. Olive oil for eating, cooking and for making soap came from north Africa and Spain. Food and liquids were transported in huge ships – the equivalent of our super-tankers.

> I decided to go into business and built five ships, loaded them with wine and sent them to Rome … All the ships sank … So I built bigger ones and filled them with wine, bacon, beans, perfume and slaves. Now I've built a house and bought slaves and cattle. Petronius

THE SIZE OF TRADE

Because Rome was so big it needed enormous amounts of imported goods. Roman shipwrecks found near France and Italy are full of large clay jars for liquids, *amphorae* – some have over 5,000 amphorae on board. Today in Rome we can see real proof of just how big and important trade was between the city and its empire. In the south of Rome there is a hill called Monte Testaccio. It is about fifty metres high and one hundred and seventy metres long. But this isn't one of Rome's famous seven hills. This hill was entirely man-

made! Its name means 'old pot hill' and the hill is built entirely of broken and dumped *amphorae* used to bring olive oil to Rome from Spain and north Africa. The Romans really had a very modern economy.

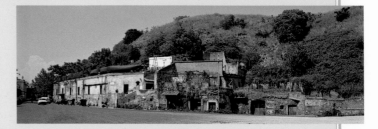

The companies who managed Roman trade were very organized. At major ports such as Alexandria in Egypt, Carthage in Africa (modern Tunisia) or Pozzuoli or Ostia in Italy, there were specially-built customs houses, import–export offices and enormous warehouses for storing goods.

In Ostia the shipping companies, especially the corn importers, were mostly based in a square behind the theatre, called Company Square.

Mosaic from Company Square, Ostia, showing an oil amphora with two palm trees.

Bronze coin showing Ostia, the bustling port of Rome.

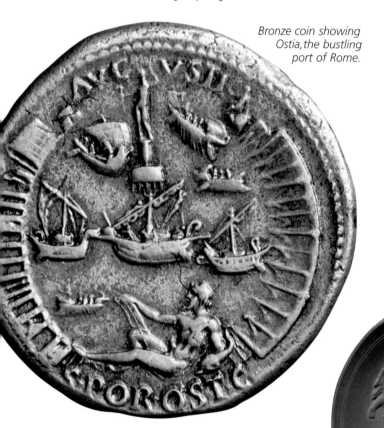

Each office had a mosaic floor that showed which part of the Roman empire they traded with. Other merchants brought luxury goods, such as fine fabrics, spices, or exotic animals and, sadly, even people. Once the goods arrived at the ports they were distributed and sold across Italy and the empire. Raw materials and finished goods went to craftsmen and shopkeepers. Just like today, shops came in all shapes and sizes and the streets of all the towns and cities of the empire were filled with them, selling everything from food and clothing to furniture, metal goods and luxuries such as jewellery. Very often the shopkeeper was also the craftsman. He made things in his workshop, sold them in the shop, and lived in the rooms above.

Red slip-ware bowl from Tunisia. Imports like these travelled with the big cargoes of oil, corn and wine.

There's a bookshop near the Forum of Caesar with adverts for poetry books pasted all over it.

Martial

A set of bronze scales.

WEIGHTS AND MEASURES

The government realized that the people of the empire, especially the poor, were very dependent on shops for their food. So to stop shopkeepers cheating, they organized sets of standard weights and measures in every major town and city. Some emperors even tried to set price limits on essential things like bread, wine and pork.

MALLS AND MARKETS

In Rome, of course, shops were bigger and better than elsewhere in the empire. Very expensive, boutique-like shops were set under the arches of the great covered basilicas in the Roman Forum, and the emperor Trajan built a massive complex of shops and offices as part of his new Forum. The curved front of part of the markets can still be seen today. There are great covered halls, five levels of shops and offices. Even roads were included in the design, so you could drive away with your shopping!

Market stalls could be found all over the Roman world. Sometimes they were fixed, but mostly stall-holders travelled around, like today, from town to town on market days and holidays. The Romans had very complex calendars to work out market days. Archaeologists in Pompeii have found lists of places and dates scratched on the walls, to remind people of the market days in different places.

There were stalls all around places like the Colosseum on fight days, selling food and souvenirs.

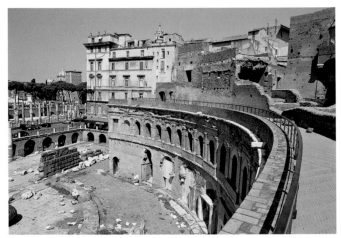

The multi-storey 'shopping centre' of Trajan's market in Rome.

The ruins of a public bakery in Pompeii, with an oven and several mills for grinding corn.

12 CRAFTSMEN AND ARTISTS

Rome's culture and art were based on Greece, but the Romans didn't just copy Greek ideas. Instead they gave them a Roman twist.

Gravestone of two craftsmen, a maker of coins and a carpenter, with pictures of their tools.

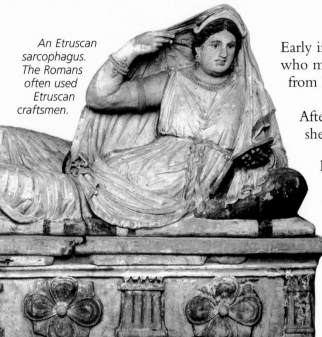

An Etruscan sarcophagus. The Romans often used Etruscan craftsmen.

Early in Rome's history, many of the city's artists and craftsmen who made beautiful objects out of terracotta and metal came from Etruria to the north of Rome.

After Rome conquered the lands around the Mediterranean she took ideas and craftsmen from the Greek world.

Dozens of workshops sprang up in Rome, making beautiful objects out of stone, bronze, silver, glass, ivory and amber. The names on signed artworks are often Greek, so we know that they often came from Greece.

MOSAICS

The Romans loved mosaics and wall paintings and put them in their houses and temples. Mosaics were invented by the Greeks, who made them from stone cubes called *tesserae*. The Romans started to use glass cubes, which were much lighter, so they could put mosaics on the walls and even ceilings.

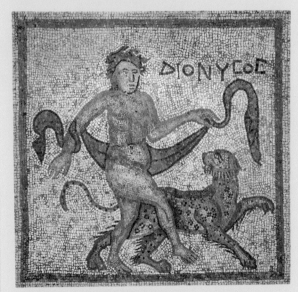

A Roman mosaic with Dionysus and his panther.

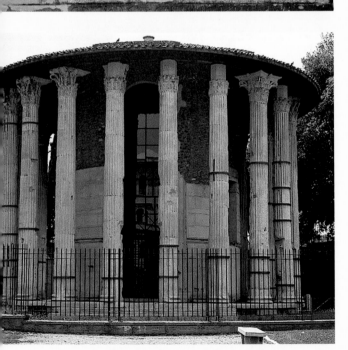

The temple of Hercules in Rome. It was built by Greek craftsmen using the finest Greek marble.

PAINTINGS AND STATUES

Wall painting from Pompeii showing the Greek hero Odysseus and the Sirens.

The Romans first saw wall paintings in Greek lands and soon adopted them. Greeks used simple blocks of bright colour, but the Romans added panels showing scenes from Greek mythology, or daily life in the city. They even painted the ceilings of their rooms. The houses of well-off Romans were very colourful!

The Romans also put thousands of statues into their houses, public buildings and squares.

They wanted the best – and that meant Greek. Rich people could bring back original bronze or marble sculptures from Greece. But if the original had already gone you could get a copy made. Many sculpture workshops sprang up, copying statues of gods and heroes. Walking round Rome you could see twenty copies of the same statue of Venus, fifteen Apollos and dozens of images of Hercules.

Roman marble statue of a discus-thrower, copied from a Greek bronze original.

JEWELLERY

Jewellery was very popular everywhere. Some fashions were universal. Women from Egypt to Britain wore snake-shaped bracelets, gold ball earrings and crescent-shaped pendants.

The empire's trade links brought exotic gems and jewels from far beyond its frontiers.

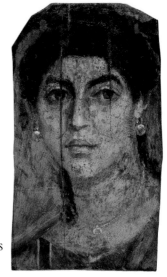

A mummy portrait from Roman Egypt showing a Roman lady wearing fine gold jewellery.

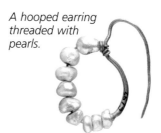

A hooped earring threaded with pearls.

Brooches, finger rings and earrings were set with imported gemstones such as blue sapphires and purple amethysts from Sri Lanka and milky white pearls from India.

SILVER

One of the finest of the Roman arts was silver-working. Workshops in Italy produced sets of silver tableware for rich people.

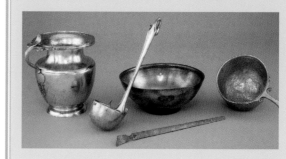

A silver drinking set.

GLASS AND POTTERY

Artists didn't just work for the rich – even poorer people could use beautiful things. During the time of the empire fine pottery and glass became available, even to the not so rich. Glass had been invented thousands of years before, but the Romans invented glass-blowing.

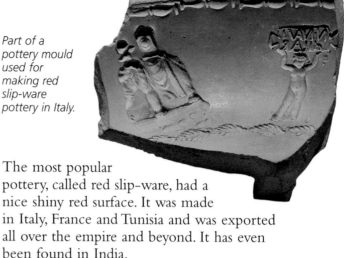

Part of a pottery mould used for making red slip-ware pottery in Italy.

Glass-blowing meant that bottles, cups and jars could be made quickly and cheaply. Pottery was also mass-produced in moulds, in workshops in Italy, France and north Africa.

A glass beaker decorated to look like silver.

The most popular pottery, called red slip-ware, had a nice shiny red surface. It was made in Italy, France and Tunisia and was exported all over the empire and beyond. It has even been found in India.

On the table red-ware has a high reputation. It is made in Arezzo in Italy and Spain and Turkey …it is carried far across the seas.

Pliny

Each set contained drinking cups, plates for serving and eating and other vessels including jugs and strainers (for getting the bits out of wine). There were also pepper pots for serving valuable Indian spices, and small silver statuettes of gods and goddesses to protect the diners while they were eating.

A small statuette of the goddess Fortuna. Above her head are the gods of the days of the week.

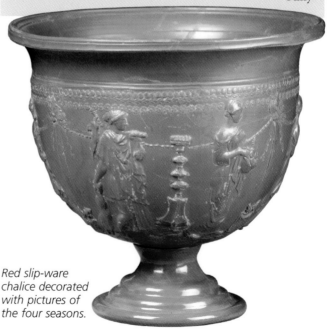

Red slip-ware chalice decorated with pictures of the four seasons.

13 ACTORS AND PERFORMERS

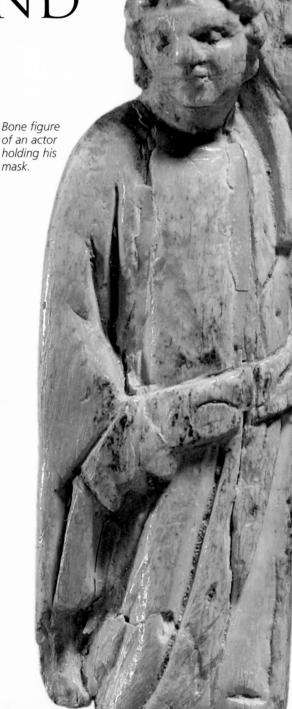

The Romans loved going to the theatre. They enjoyed plays written many years before by Greeks – the tragedies (sad stories) of Euripides, or the comedies (funny stories) of Menander. They also loved comedies by Roman writers, and plays rather like pantomimes.

Bone figure of an actor holding his mask.

One of the earliest Roman playwrights was a man called Plautus, who lived in about 220 BC. He wrote comedies in the Greek style, but gave them some Roman characters, such as the clever slave, the big-headed soldier, the silly old man and the modest girl. About twenty of Plautus's plays survived. The English writer William Shakespeare copied some of Plautus' plots and characters for his own comedies.

Terracotta figurine of an actor wearing a mask.

THEATRES

Every major town and city had a theatre. They were large semicircular buildings, often the biggest structure in the city. Theatres were solidly constructed of stone, brick and concrete. Many theatres still stand today because after the empire ended they were reused as houses or forts. The semicircle of seats, or *cavea*, was very steep so that everyone could get a good view. The centre of the action was the stage – the *scaena*, with a stage building or *scaenae frons* two or three storeys high, decorated with marble columns and statues. The actors appeared out of three different doorways, creating funny and confusing comings and goings.

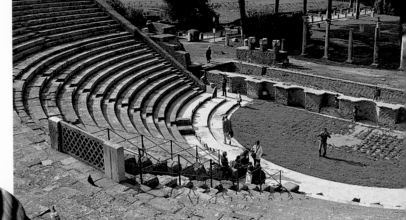

The theatre at Ostia.

Hadrian, in honour of his predecessor Trajan, ordered the theatre seats to be sprayed with perfume.

Historia Augusta

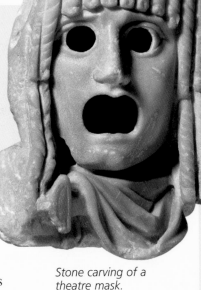

Stone carving of a theatre mask.

In Greek and Roman plays actors wore distinctive costumes and masks, to tell the audience which character they were. To make the actors easier to see they wore shoes with platform soles! The most common masks showed faces with exaggerated smiles for happy or lucky characters, and huge frowns for unhappy or angry ones.

In Greece, the theatre was part of a festival for the god Dionysus (Roman Bacchus), so actors were very important. But the Romans thought acting was not respectable at all. Women were not allowed to be actors, so all women's parts were played by men. Nobody from the aristocracy could become an actor, and the Romans passed laws that prevented actors from taking part in public life. But this didn't stop the emperor Nero.

Nero made his stage debut at Naples. He sang and sang and did not stop, even when an earthquake rocked the theatre.

Suetonius

While he (Nero) sang, no one could leave the theatre even in an emergency. Some women had to give birth there, others leapt out over the outside wall, or even pretended they had died.

Suetonius

MUSIC

Music accompanied the action during performances in the theatre. In fact, music was a vital part of every important event, from weddings, funerals and religious ceremonies, to shows in the theatre, arena and circus.

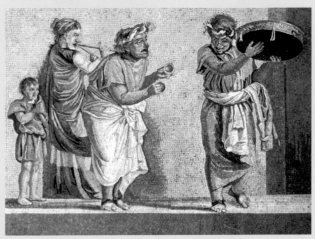

A mosaic from Pompeii showing a band of street musicians.

There were also groups of musicians who went from town to town playing popular and traditional music.

Wall paintings, mosaics and sculptures show what Roman musical instruments looked like. Archaeologists have found the remains of some real instruments. Wind instruments included two different types of trumpet – the large circular *cornu*, taken over from the Etruscans, and the long straight *tuba*. Both trumpets were also used by the army to give signals in battle.

A bronze cornu.

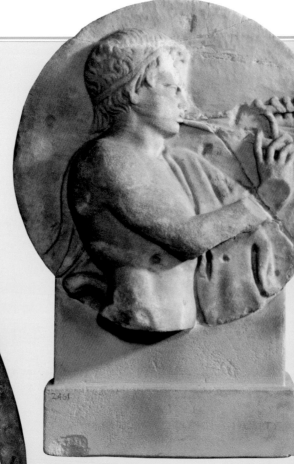

Stone relief of a young man playing the aulos.

The Romans also used the Greek flute (*aulos* or *tibia*), which was sometimes played in pairs. For percussion the Romans used drums, the tambourine (*tympanum*), castanets and the rattle (*sistrum*).

The most complex instrument of all was the organ, with a series of pipes of different sizes and lengths that made a range of noises when air was pushed through them. Roman organs used water to increase the pressure and make the sounds.

Stringed instruments were popular. One was the lute – the ancestor of the modern guitar. The oldest and most famous was the lyre. This had a sound-box and two tall arms which supported the crossbar to which the strings were attached.

The Romans preferred a heavy version of the lyre called a *kithara*, because it gave a louder and more wide-ranging sound. This was a favourite instrument for artists and musicians and it was the instrument that the emperor Nero used to accompany his songs and poetry.

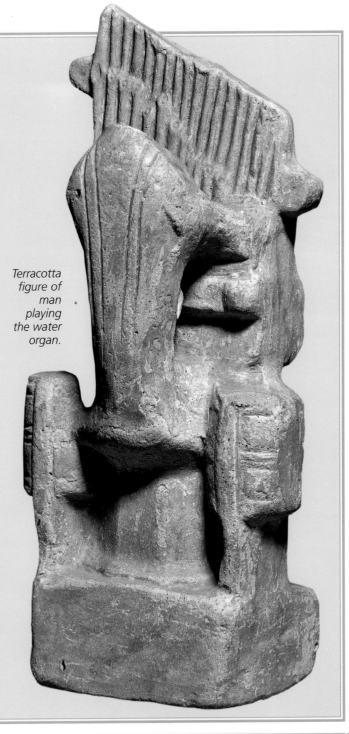

Terracotta figure of man playing the water organ.

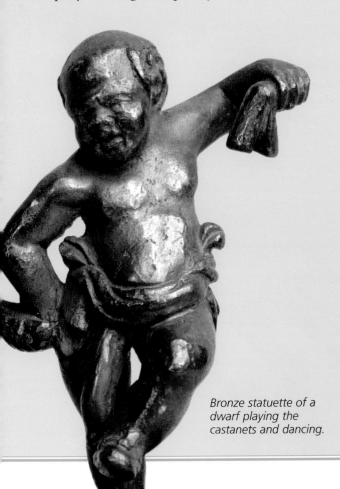

Bronze statuette of a dwarf playing the castanets and dancing.

14 CHARIOTEERS

Chariot racing was the most popular form of entertainment in the Roman world, after gladiator fights. At first, chariot races were held on holy days as part of religious ceremonies. Gradually people came to expect more and more races and they became part of the normal calendar of events.

> All Rome is at the circus today.
>
> Juvenal

Legend says that the first races in Rome were held by Rome's first king, Romulus, in the valley below the Palatine Hill. About a hundred years later another king, Tarquin, built the first fixed race-track, called a 'circus'. The circus had a very special shape, long and thin with one flat end and one rounded end.

The Circus Maximus was the largest and most important of Rome's five public circuses for chariot and horse racing. In fact, it was the biggest structure for spectacular entertainment in the empire. It was 600 m long and 180 m wide and could hold almost 200,000 spectators on more than 30 km of seating.

Racing chariots were very light, not like the great heavy chariots sometimes seen on films and television. They were built for speed, and there were several different types. Charioteers raced in everything from a two-horse chariot (*biga*) to a twelve-horse monster! But their favourite was the four-horse chariot, the *quadriga*.

Bronze model of a biga, a two-horse chariot.

THE CIRCUS MAXIMUS

The Roman writer Juvenal famously remarked:

> ... the people of Rome crave only two things, bread and circuses.

Politicians knew how important the Circus was, so they spent a lot of money improving it to keep people happy (and for their own glory). Julius Caesar rebuilt most of the Circus Maximus in stone and the emperor Augustus added a royal box to give the imperial family a grandstand view from the Palatine Hill. The upper tier, still made of wood, was damaged by fire on several occasions. Rome's most famous fire – the Great Fire of Nero in AD 64 - started in the small shops and taverns huddled around the Circus. The wooden parts of the Circus collapsed completely in about AD 300, during Diocletian's reign, and writers reported that over 10,000 people were killed.

Down the centre of the track ran the central reserve, or *spina*, crammed with temples, shrines and other monuments, including two colossal obelisks brought from Egypt.

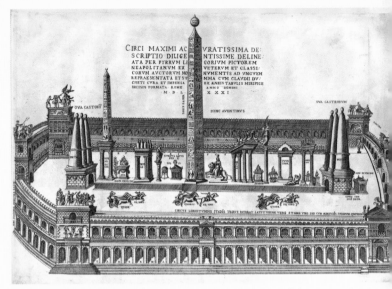

A print of 1581 showing an imaginary reconstruction of the Circus Maximus in Rome.

A normal race was seven laps around the track – a full distance of about six kilometres (four miles).

On each end of the *spina* was a huge turning-post (*meta*), with a clever way of telling the charioteers (and the audience) how many laps had been completed. At one end were seven huge bronze eggs, and at the other end were seven bronze dolphins, which dipped at the end of each lap.

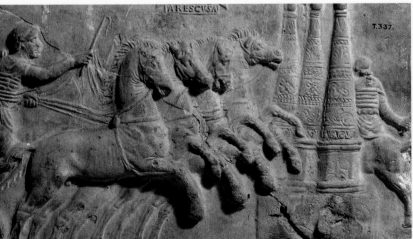

Terracotta plaque showing a quadriga, a four-horse chariot. This was the Romans' favourite kind of racing chariot.

An oil lamp with chariots rushing out of the starting gates in the Circus Maximus.

TEAMS AND FANS

At a race, emotions ran very high. The excited crowd supported four different chariot teams. Each team wore coloured jackets – red, white, green and blue. Everyone felt close to the action. There were dozens of off-track entertainments, too. Food and drink sellers strolled through the aisles, and gamblers laid bets on the race results, and. Even the emperors liked to bet.

There were other, more romantic attractions. When the emperor Vespasian built the Colosseum it had a rigid seating system – women could only sit in the very top seats. But at the Circus, men and women could sit together. The writer Ovid, in his *Arts of Love*, said the Circus was a wonderful place to meet girls.

> Go to the circus … you can sit close to her … find out her favourite horse, then back it yourself … 'Helpfully' brush the dust from her robes (even if they are not dusty) … plump up her cushion … protect her from the elbows and knees of fellow spectators … and offer to fan her with your programme. You're bound to find love in that crowd.

Many images of charioteers survive, showing them wearing distinctive banded and padded jackets and special caps – perhaps like modern crash helmets. During a race the charioteer wrapped the reins of the horses around his waist to help guide them. He carried a sharp knife so he could cut the reins and jump free if his chariot crashed. The sport was very dangerous, but prize money for races in the Circus Maximus could be huge. A gravestone in Rome commemorates Gaius Appuleius Diocles, a charioteer from Lusitania (modern Portugal). He competed in over 4,000 races in the early second century AD and built up an enormous fortune.

Ivory statuette of a charioteer wearing a banded jacket and carrying a palm branch of victory.

THE 'RACE OF LIFE'

The crowd adored charioteers.

Chariot racing was so popular that people used scenes of races, chariots, or even just the winning horses to decorate everyday objects. Oil lamps, floor mosaics and even burial chests (*sarcophagi*) were covered in action-filled scenes of chariots thundering around the track. Sometimes they were very realistic, but they could be pure fantasy, showing chariots driven by cupids or even monkeys! On burial chests scenes of chariots racing had a special importance, because writers and philosophers said that the race-track was a symbol of the continual race of our day to day lives.

A winning horse is celebrated on an oil lamp.

A lead burial chest showing a chariot.

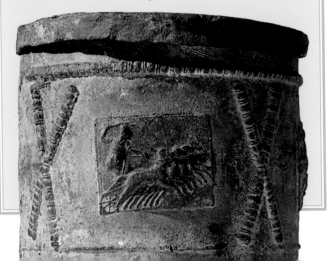

Chariot racing remained popular until the end of the Roman empire. A Gaulish landowner called Rutilius Namatianus visited Rome in AD 416, six years after the city had been burnt by the barbarians. Even then, the games were still very popular. He said the roar of the crowd could be heard half way to the port at Ostia. The last recorded event was held around AD 540, after which there was no need for such a big circus – or any circus at all. The huge structure began to fall into ruins. In the Middle Ages the Circus was plundered for stone so that today only scraps of the structure survive. Now where a quarter of a million Romans used to scream and shout for their teams, all we can see is a huge green valley by the side of the Palatine Hill.

The remains of the Circus Maximus today.

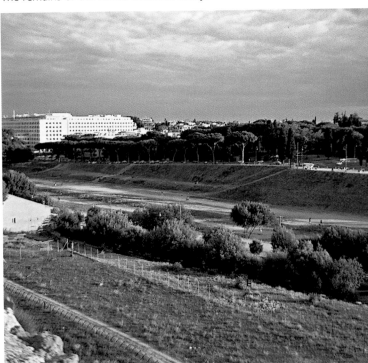

15 GLADIATORS

Gladiators were the favourite entertainers of ancient Rome and are still loved today. For the crowds that came to the arena (or amphitheatre), gladiators were celebrities, just like our film and television stars, sports personalities and singers, all rolled into one.

Bronze helmet of a murmillo gladiator.

Maximus fights another gladiator and a tiger in the 2000 film Gladiator. *In reality, gladiators did not fight animals.*

Gladiators could be condemned criminals, prisoners of war and sometimes even volunteers. They were sent to a special military-style barracks for gladiators, a *ludus*. Once inside they were slaves, the property of their trainer (*lanista*). The training was very hard and the punishments extremely cruel, so why did people do it? Some wanted to win prizes, get rich and buy their freedom, others also wanted to be famous and loved by the people. Even some of the emperors, such as Commodus, liked to fight in the arena. People thought gladiators were very attractive.

> A senator's wife, Eppia, fell for a gladiator, Sergius. He was at least forty, with a bad arm, a scarred face and an eye oozing pus – but he was a gladiator. This made him seem *very* handsome.
>
> Juvenal

Gladiators fought on about thirty days in the year – more if the emperor wanted to celebrate a special event. Days in advance, painted advertisements were put on walls throughout the city, saying when the fights would be held, how many gladiators would compete, and who the sponsor was. Games needed rich sponsors because the animals, hunters and gladiators were very expensive.

Oil lamp showing an acrobat pole-vaulting over a bull. Acrobats performed in the arena before the gladiator fights.

THE COLOSSEUM

Gladiators fought in an amphitheatre, or arena – named after the Latin word for sand, *harena*. Sand was spread thickly on the floor to soak up all the blood. The largest and most famous arena in the empire was the Colosseum in Rome, which held about 70,000 people. Its ruins are still Rome's most recognizable structure. Seats were strictly reserved, with a special box for the imperial family. In the front rows were the priests and senators, then came the knights, other rich people, then the ordinary citizens and finally, right at the top, women and slaves.

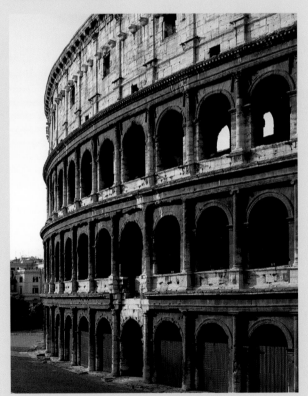

The Colosseum, the largest arena in the empire.

A DAY AT THE ARENA

The day's events started with a grand parade, the *pompa*. Then came entertaining warm-up acts such as jugglers, acrobats and even performing animals. Monkeys fought in soldiers' uniforms and elephants balanced on their back legs or bowed down in front of the emperor. Then the mood changed as animals fought animals and afterwards animals fought men. These men were not gladiators, but hunters (*venatores*), specially trained animal-fighters.

> At Athens Hadrian put on a hunt of a thousand wild beasts.
>
> Historia Augusta

> When Titus opened his amphitheatre (the Colosseum) he exhibited (and killed) five thousand wild animals of all types in a single day.
>
> Suetonius

The morning finished with horribly cruel executions of criminals. These criminals (*noxii*), guilty of crimes such as murder or treason, were burned alive, crucified (nailed to wooden crosses) or thrown to the beasts. The prisoners who fought the beasts were untrained, and often in chains, so they stood no chance against wild and hungry animals. Then it was time to have lunch ...

A terracotta plaque of a panther attacking a venator (hunter).

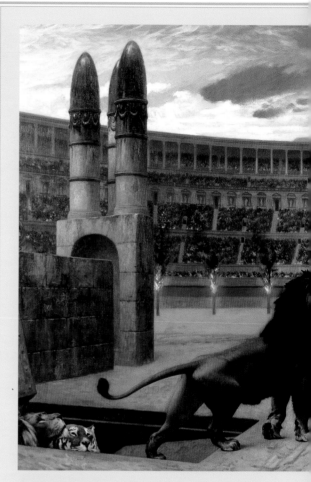

Some of the people executed in the arena were Christians. Emperors such as Nero were very suspicious of the new religion, and they condemned thousands of Christians to die as *noxii*.

It was horribly cruel, but the bravery of the Christians, facing death for what they believed, inspired many others to desert the Roman gods.

HEROES OF THE ARENA

In the afternoon came the gladiators. The crowds had seen plenty of blood already, so with the gladiators they wanted to see skill and bravery. There were different types of gladiators, with special armour, who were trained to fight in a particular way. The *murmillo* was fully armed with a large shield and a heavy helmet. He relied on his heavy armour for protection.

The gladiator he usually fought against was the *Thraex* (Thracian) more lightly armed, with long leg-guards, and a small shield. He had a very distinctive sword, with a curved end that could stab up behind his enemy's shield.

Many artists have been inspired by events in the Roman arena. This picture, The Christian Martyr's Last Prayer, *was painted by Jean-Léon Gérôme in 1883. It shows Christians about to be torn to pieces by lions and tigers.*

> They were disguised in animal skins so that dogs tore them to pieces, they were tied to crosses or set on fire and used as human torches by night …
>
> Tacitus

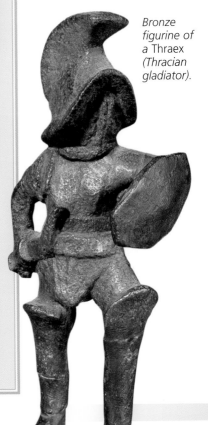

Bronze figurine of a Thraex (Thracian gladiator).

Marble gravestone of a gladiator called Hilarus.

Glass drinking vessel – turn it upside down like this, and it becomes a secutor's helmet.

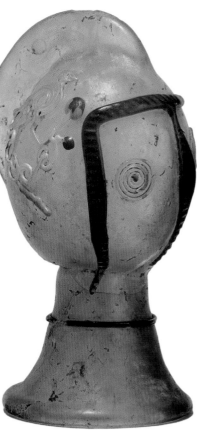

Base of a glass bowl, showing a retiarius (net fighter) called Stratonicus.

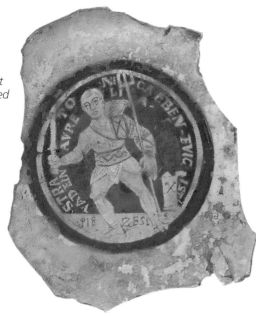

A *retiarius* (net-fighter) was almost unarmed, except for a metal shoulder guard, but he was fast and could catch opponents in his net and stab them with his three-pronged trident. His opponent the *secutor* (chaser) had a rather scary helmet with trident-proof eye-holes.

Fights didn't last for very long, because gladiators became exhausted or were wounded.
A gladiator could stop a fight by putting down his shield and raising his hand. The fight stopped and the emperor asked the audience what to do.

This nineteenth-century painting by Jean-Léon Gérôme is called Pollice Verso. *The winning gladiator is asking the emperor whether to kill, or spare, his defeated opponent.*

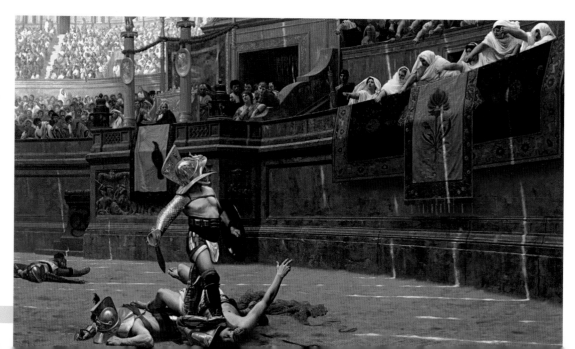

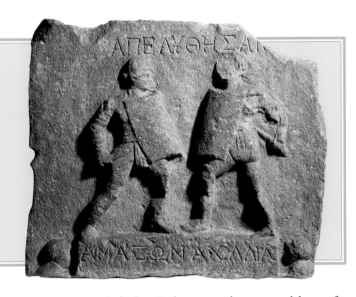

FEMALE GLADIATORS

Not all gladiators were men. The emperor Domitian organized fights between female gladiators at night, and illuminated the Colosseum with torches, while other women fought on chariots. A carved stone relief, now in the British Museum, shows two women, Amazon and Achillia. They fought as gladiators in Halicarnassus (now Bodrum in modern Turkey). Happily, the relief tells us they were both allowed to leave the arena alive.

If the gladiator had fought well the crowd shouted 'Mitte! Mitte!' (Let him go! Let him go!), and he left the arena with honour. If the crowd didn't like him they shouted 'Iugula! Iugula!' (Slit his throat! Slit his throat!). A clever emperor agreed with the crowd – if not, the people could get very angry and even riot. Thousands of gladiators died in the arena but many left it alive and enjoyed a comfortable retirement. Some even opened their own gladiator schools – preparing the next generation of fighters.

As spectators left the Colosseum they passed lots of stalls and shops selling souvenirs. You could buy a little clay figure or a lamp showing your favourite gladiator to remind you of your day out at the arena.

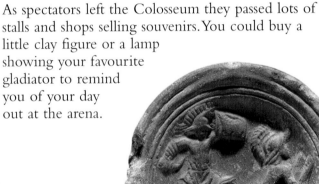

Oil lamp showing the final moments of a gladiator fight.

Terracotta figurine of a Thraex and a hoplomachus.

FIND OUT MORE

You can find out more about the Romans and the things they made on the British Museum website. Go to **www.britishmuseum.org** and click on 'Explore the British Museum'. You can explore galleries, search for people and objects, and find online tours and games.

Other books on the Romans for younger readers

Richard Abdy, *Pocket Dictionary of the Roman Army*, British Museum Press 2008

Peter Connolly, *Pompeii*, Oxford University Press, 1990

Mike Corbishley, *Illustrated Encyclopaedia of Ancient Rome*, British Museum Press 2003

Irving Finkel, *Games*, British Museum Press 2005 *(includes the Roman game Duodecim scripta)*

Judy Lindsay, *The Gladiator Activity Book*, British Museum Press 2004

Sam Moorhead, *Pocket Explorer: The Roman Empire*, British Museum Press 2008

Paul Roberts, *Pocket Dictionary of Roman Emperors*, British Museum Press 2006

Katharine Wiltshire, *Pocket Timeline of Ancient Rome*, British Museum Press 2005

Katharine Hoare, *V-Mail: Letters from the Romans at Vindolanda Fort near Hadrian's Wall*, British Museum Press 2008

Richard Woff, *Pocket Dictionary of Greek and Roman Gods and Goddesses*, British Museum Press 2003

Books for older readers

Alan K. Bowman, *Life and Letters on the Roman Frontier: Vindolanda and its People*, British Museum Press 2003

Lucilla Burn, *The British Museum Book of Greek and Roman Art*, British Museum Press 1991

Peter Connolly and Hazel Dodge, *The Ancient City: Life in Classical Athens and Rome*, Oxford University Press Inc, 2000

Ada Gabucci, *Ancient Rome: Art, Architecture and History*, British Museum Press 2002

Paul Roberts, *Mummy Portraits from Roman Egypt*, British Museum Press 2008

Christopher Scarre, *Chronicle of the Roman Emperors*, Thames and Hudson 1995

INDEX